DRAWING
People

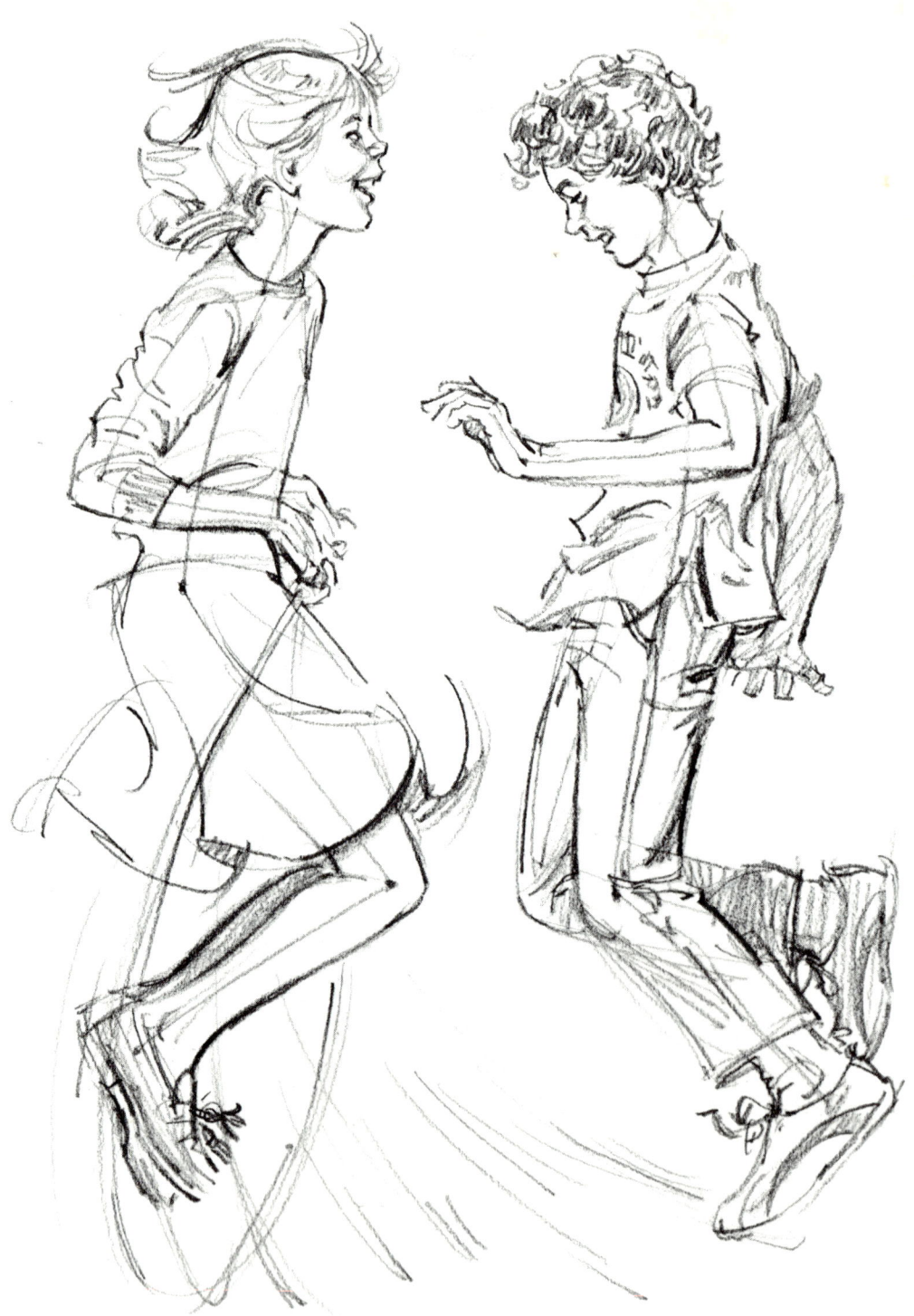

DRAWING
People
Elliot Ivenbaum
Illustrated by the author
and Paul Frame

Franklin Watts
London New York Sydney Toronto

CONTENTS

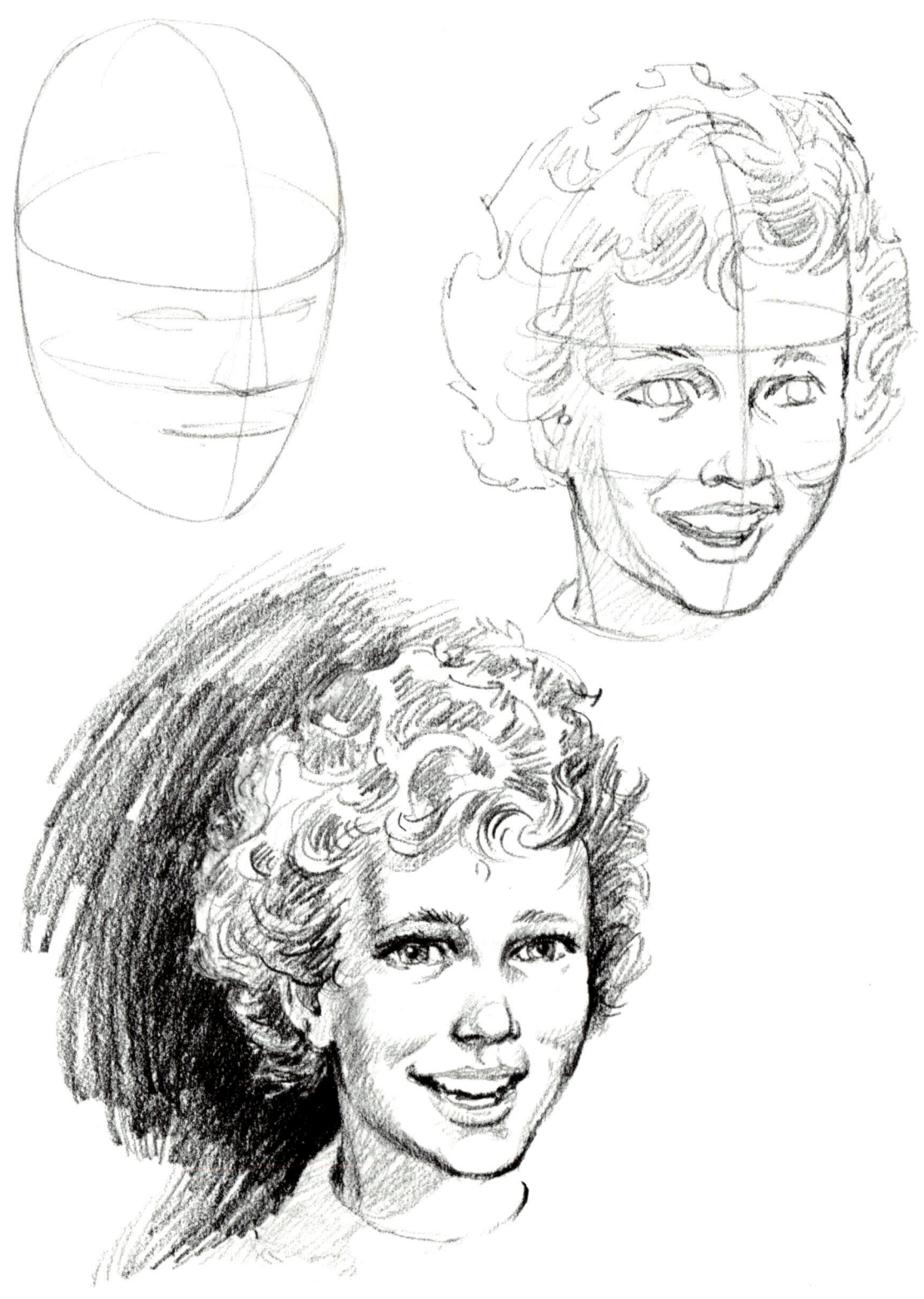

Introduction

We humans are truly remarkable creatures. We can run, jump, swim, think, talk, build cities, fly to the moon — do more things than any other animal alive, including drawing pictures of ourselves.

Why should we want to draw ourselves? There are many reasons. But perhaps the best reason of all is that it helps us know ourselves better.

In learning to draw, as in learning anything else, desire is our most important asset. Some people feel that having talent is more important, but this is not really so. Talent is mostly a built-in interest in something. How interested you are in doing something will most often determine how well you will do it. This doesn't mean that it can be done without trying. It does mean that by being interested and trying hard you can succeed.

So don't worry about whether you have talent or not. You can learn to draw as well as you want to.

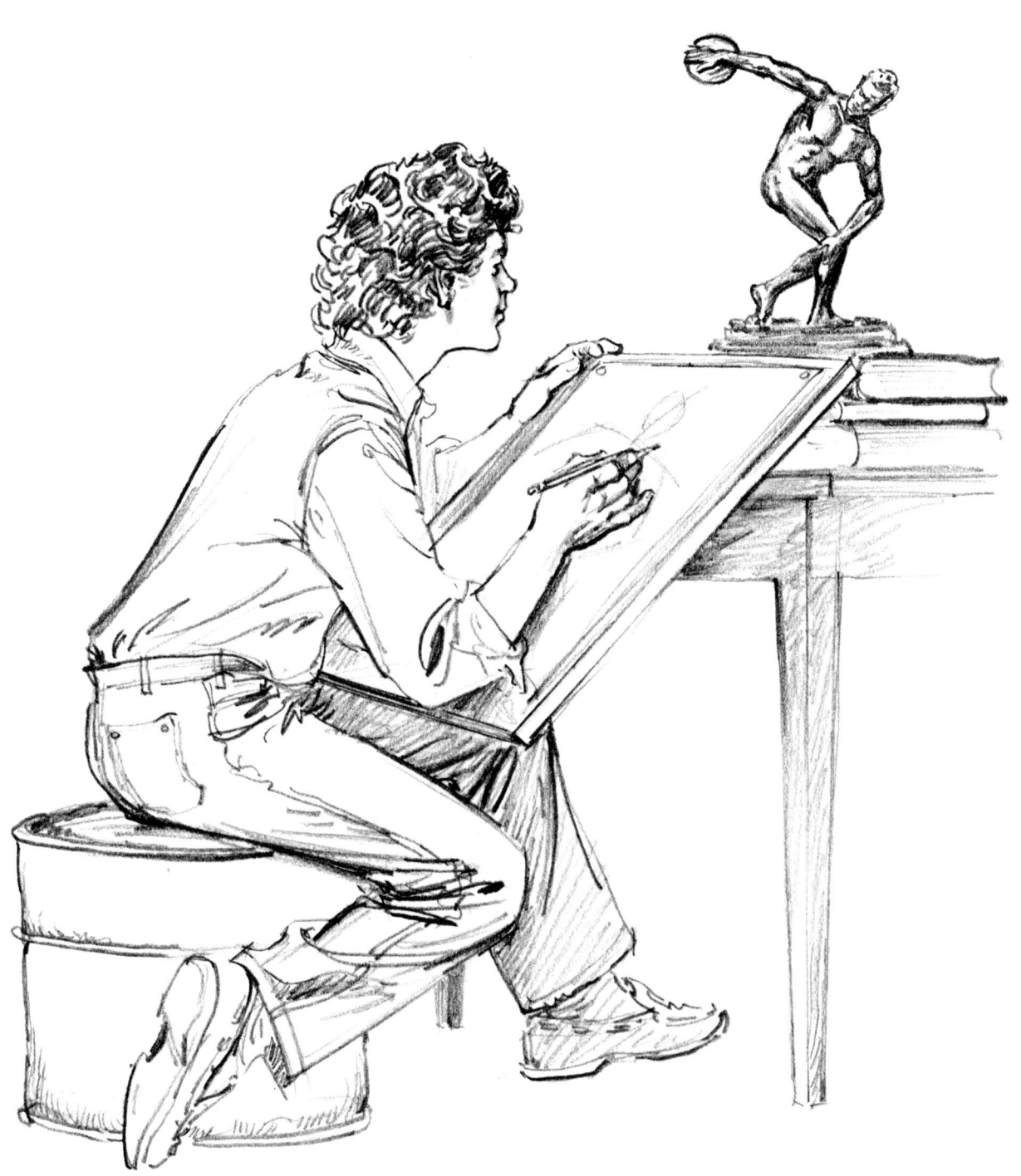

Chapter 1
Before You Begin

Drawing is not just making a duplicate of something. That's what a photograph might do. A drawing is more often an expression of how a person sees something or how he or she feels about it. Always remember this when you draw. Express yourself. Be emotional!

In order to draw people well, you must get to know the human body. The easiest way to do this is to study your own. See how your body feels when you are running. Which muscles do you use? Which do you not use? When you are sitting, how do your arms, legs, and shoulders feel? Even though we love to look for the differences in people, we are all pretty much the same. When you kneel, the blood in your legs circulates more slowly than when your legs are extended. Your muscles tighten up after a while. It is the same with the person you are drawing. So always try to imagine how you would feel if you were posed in the same way the person you are drawing is, and keep that feeling in mind as you draw.

Another important thing is to pay attention. You will find that when drawing, you must look more closely at what you are drawing than you have ever had to look at anything before. If you were studying music, you would have to listen more carefully than you usually do. If you were cooking, you would pay more attention to how things taste. So when drawing, you must *see* what you are drawing.

And finally, the hardest thing of all to do — relax. With all the seeing and feeling and understanding you must do, you will find yourself tightening up. This is only natural. When you learned how to swim, your awkwardness and fear of drowning made the activity seem unpleasant at first. But once you got used to the water, and to the basic strokes, your body relaxed, and you found moving through the water great fun. The same holds true for drawing. The sooner you become comfortable with it, the more fun it is, and the better artist you'll be.

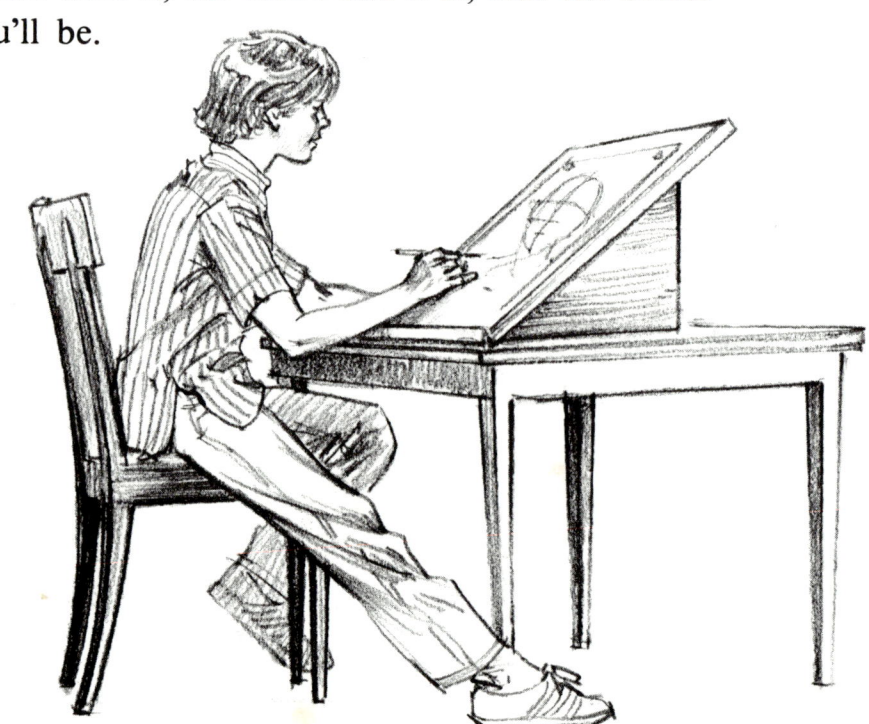

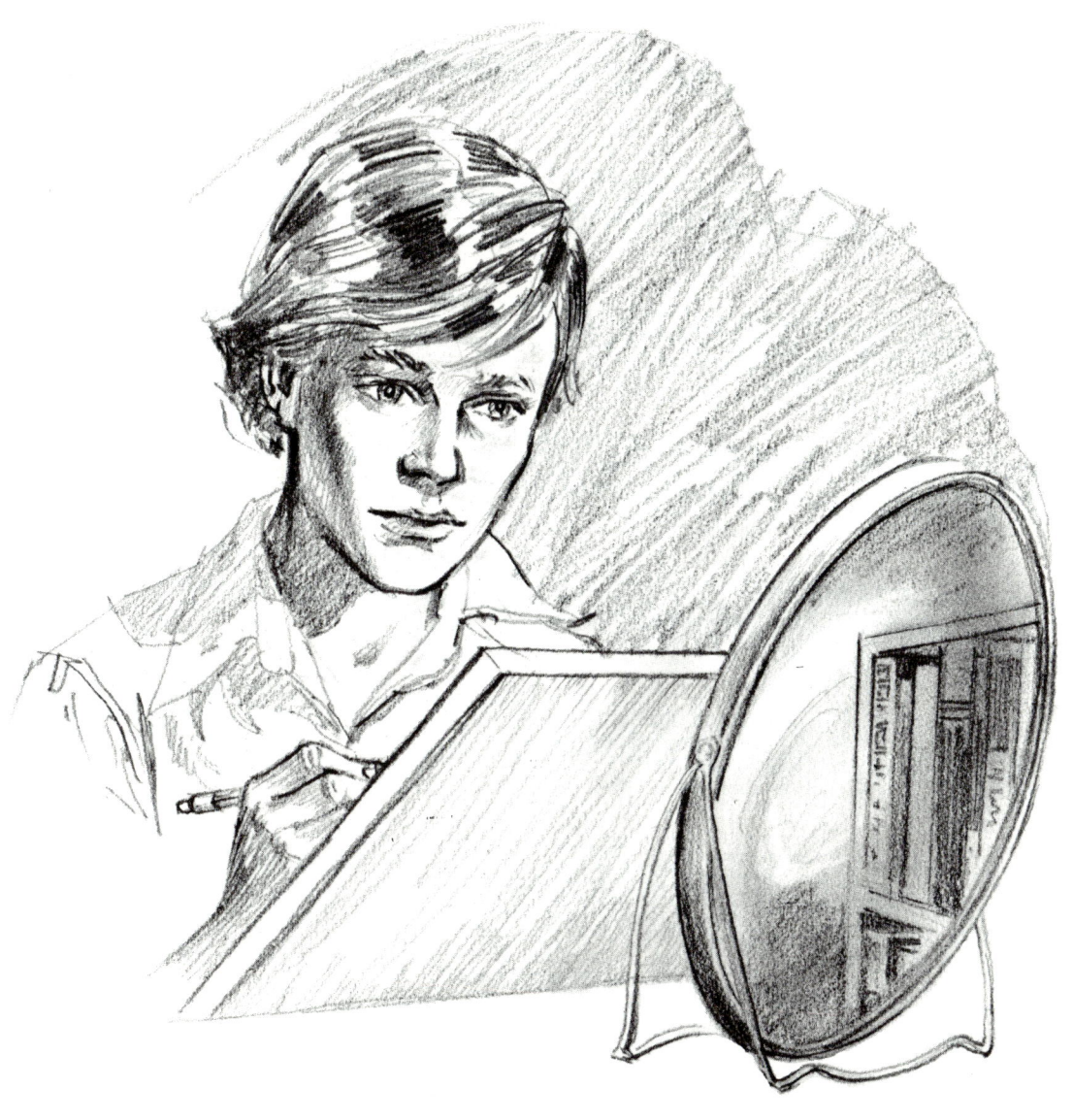

A few last words before we begin. Don't worry about how good your drawings are. When people enjoy drawing, they soon become good at it. And don't try to create a "masterpiece" right away. Our greatest artists made many bad drawings before the first good ones came.

Chapter 2
Getting Started

BASIC MATERIALS

1. *Paper.* The first thing you'll need is paper to draw on. Bond or typing paper will serve this purpose very nicely. However, since you'll want to do lots of practice drawings that can be thrown away later, you might prefer to use cheaper paper, such as paper bags or discarded wrapping paper. If there is no desk or table available to lean on, a large book or a clipboard will provide a surface. A spiral-bound sketchpad will work as well, although items like these tend to be expensive.

2. *Pencils.* The best all-around drawing tool is the pencil. With it you can get any shade of grey and still have good control. An H or HB pencil is good to start with. For very dark lines use a 2B or 4B. If you dislike having to sharpen your pencils, a lead holder or a mechanical pencil can be purchased at your local art supply store. You might also try using an ink pen, which gives dark lines with no grey tones, or a charcoal stick, which gives soft lines and subtle tones.

3. *Eraser.* We all make mistakes, so keeping an eraser handy is a good idea. Any plastic eraser is fine for eliminating large areas of a drawing. To erase small areas or to lighten pencil lines, a kneaded eraser is best.

Lead holder

Mechanical pencil

A kneaded eraser can be moulded into all kinds of shapes.

Pocket sharpener

Sandpaper block

4. *Sharpener.* A small pocket sharpener is all you really need. Some people, however, also like to use a sandpaper block, which can sharpen a pencil to a very fine point or flatten the pencil lead to a chisel shape for flat, broad strokes.

5. *Everything else.* There are many kinds of materials which can help artists do their work. Since everyone works differently, the best way to tell what you need is to experiment. The above are just the basic materials. Anything else is up to you.

Perhaps at this time you will be wondering where you can find another basic tool — a model. Wonder no more. The one model that's always ready when you are is *you*. You can draw yourself in the mirror from all angles, wearing different expressions or different clothes. You can draw parts of your body — hands, feet, elbows, anything — anytime you want. In addition, friends or family members may pose for short periods of time.

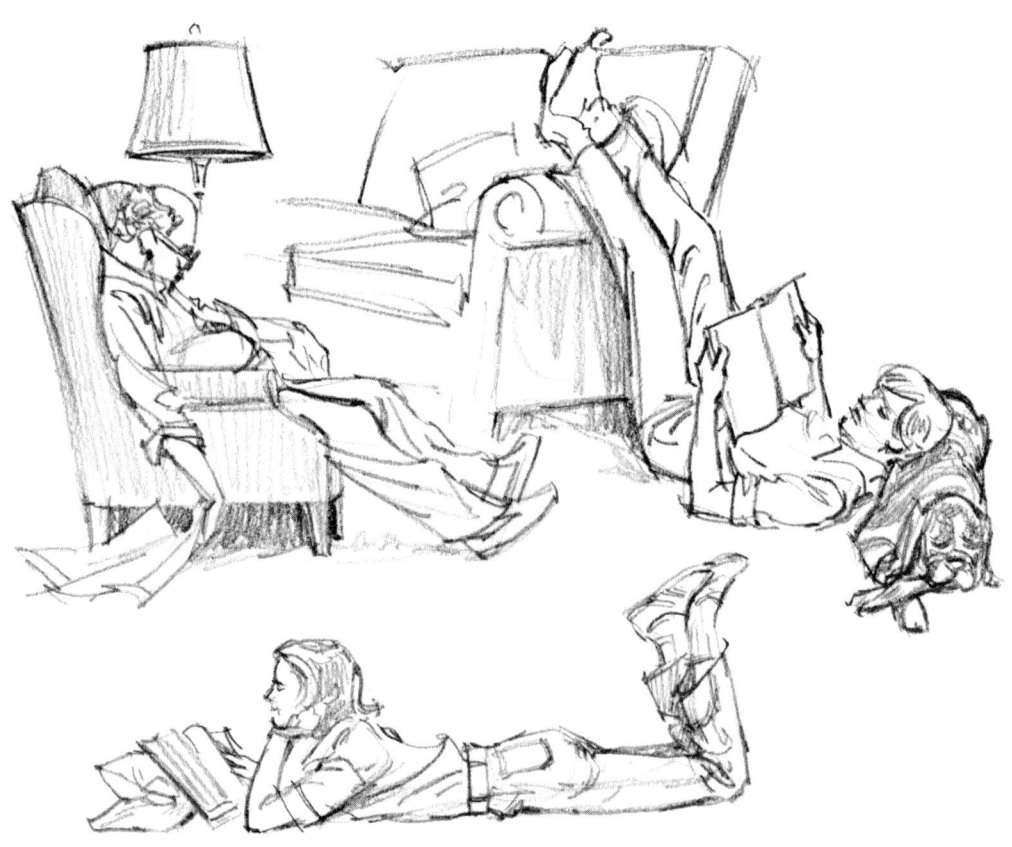

It's a good idea to take your sketchpad along with you whenever you go out. People waiting at bus stops, sunning at the beach, or sitting in the park make fine models, for example.

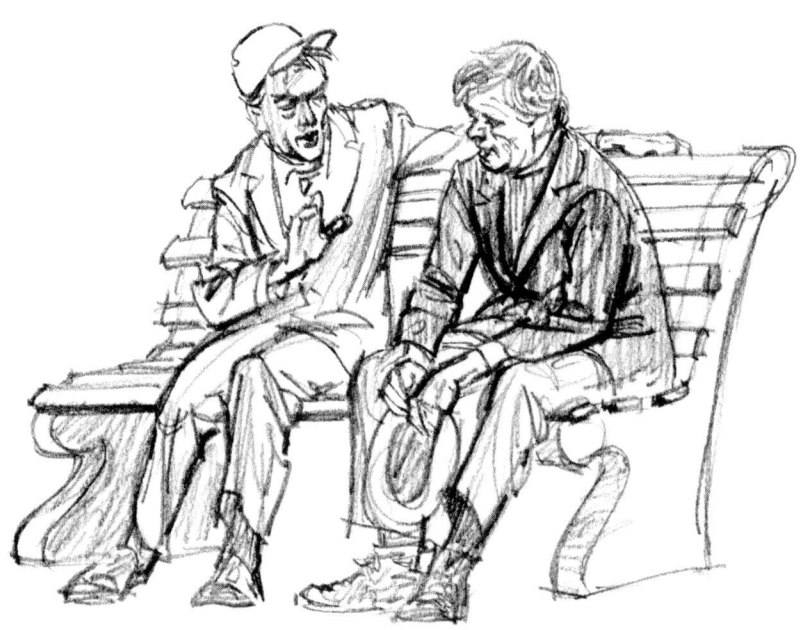

Real live people are best to draw, but in a pinch, how about using statues or plastic models? And of course there are always photographs. Books, magazines, and newspapers are good places to find interesting people doing interesting things. This very book is filled with pictures you can use. So now, let's get started!

(19)

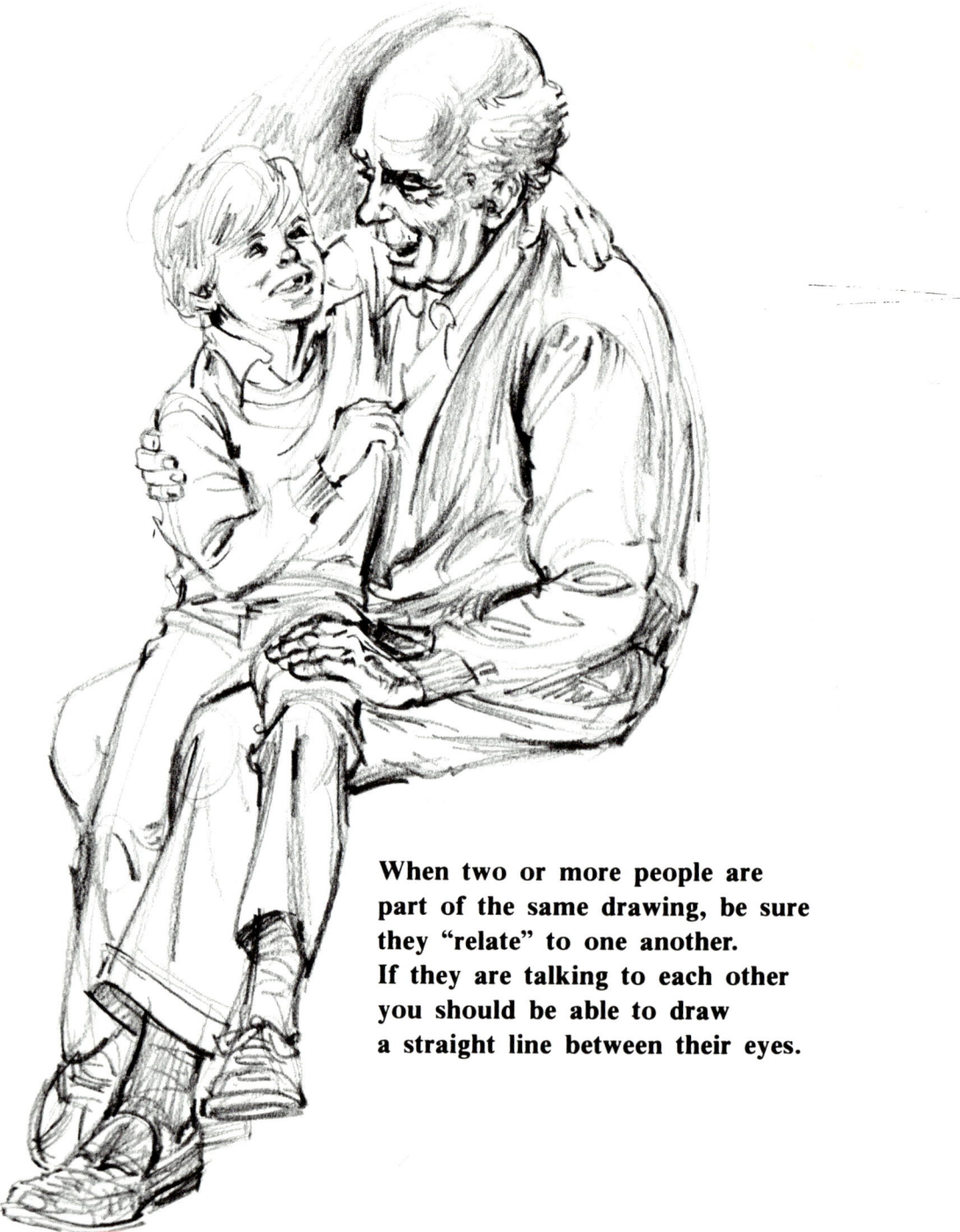

When two or more people are
part of the same drawing, be sure
they "relate" to one another.
If they are talking to each other
you should be able to draw
a straight line between their eyes.

Chapter 3
Sketching

Here are several different types of rough drawings which we call sketches. They should be thought of as preliminaries to better drawing, rather than as finished artwork.

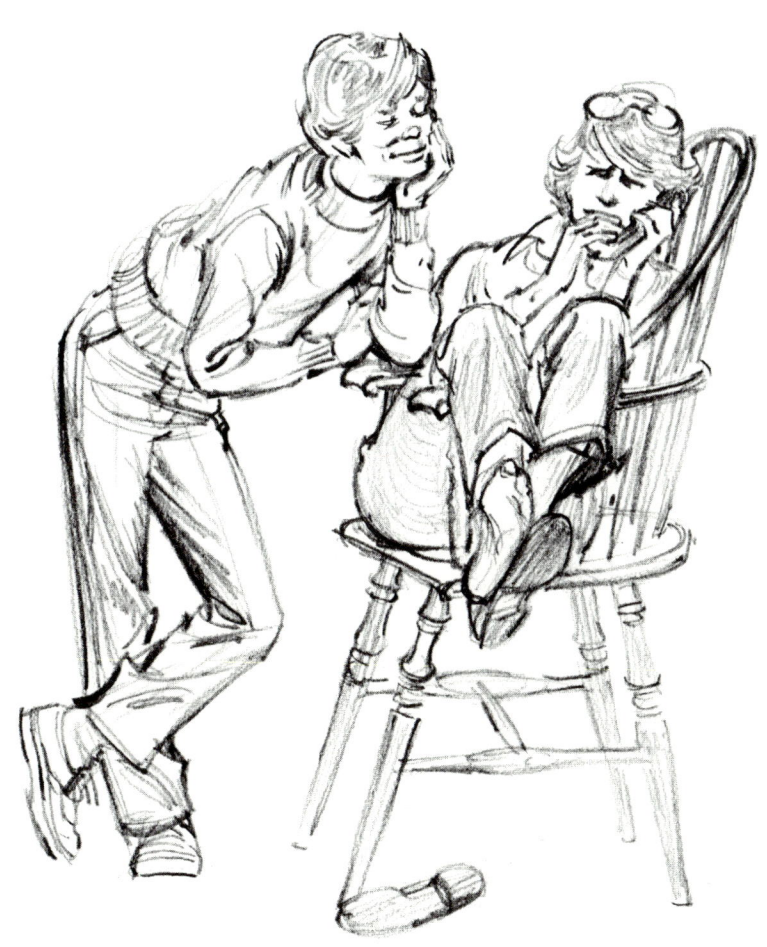

GESTURE SKETCHES

This is a good warm-up exercise. Here you should try to capture only the sense of what is happening. The model should pose for these sketches only a minute or two; no longer. As you draw, try to relax. Let the lines flow into one another smoothly and gracefully. Don't put in details. Just aim to capture the essence of the pose or the movement of the subject.

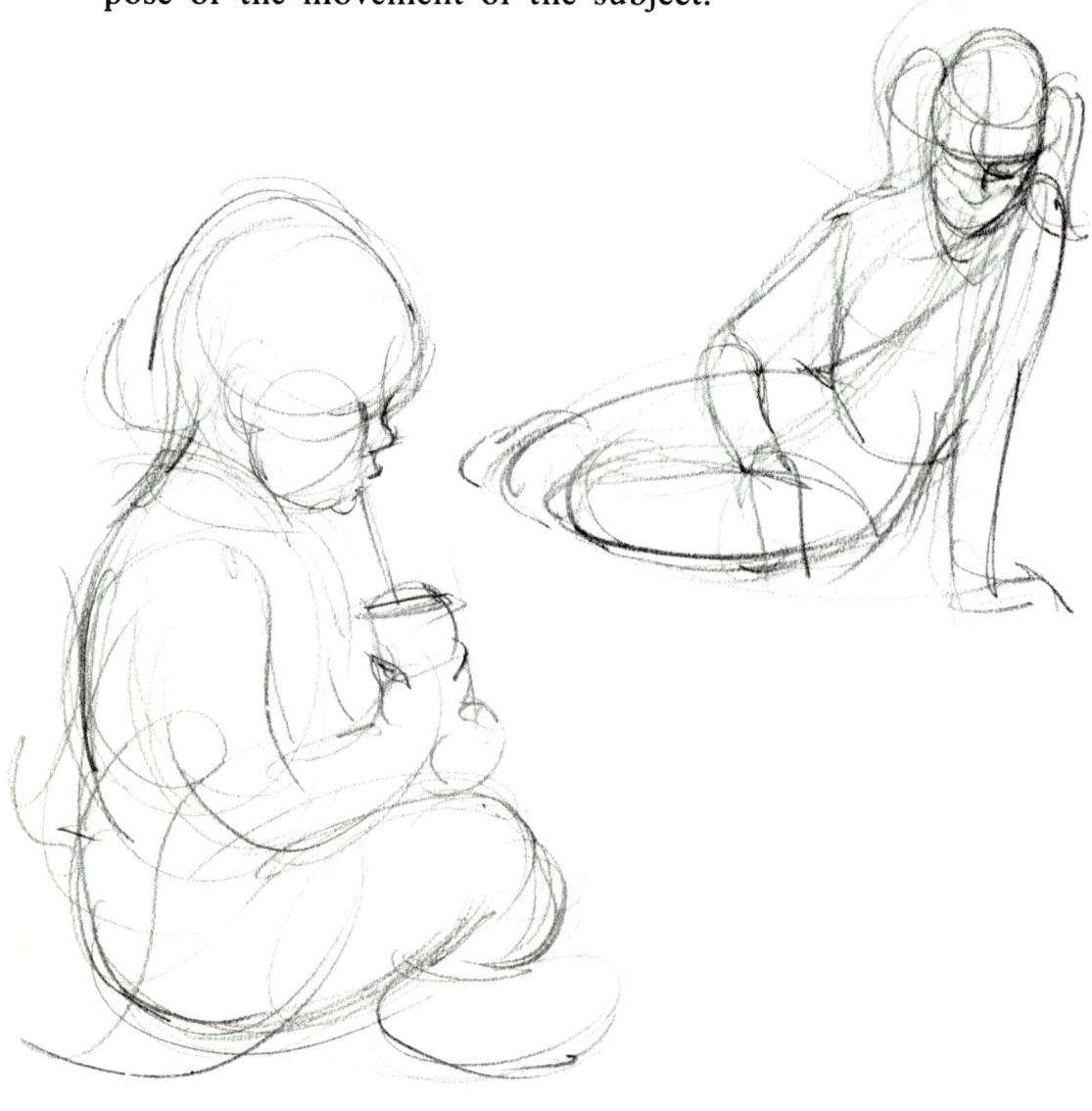

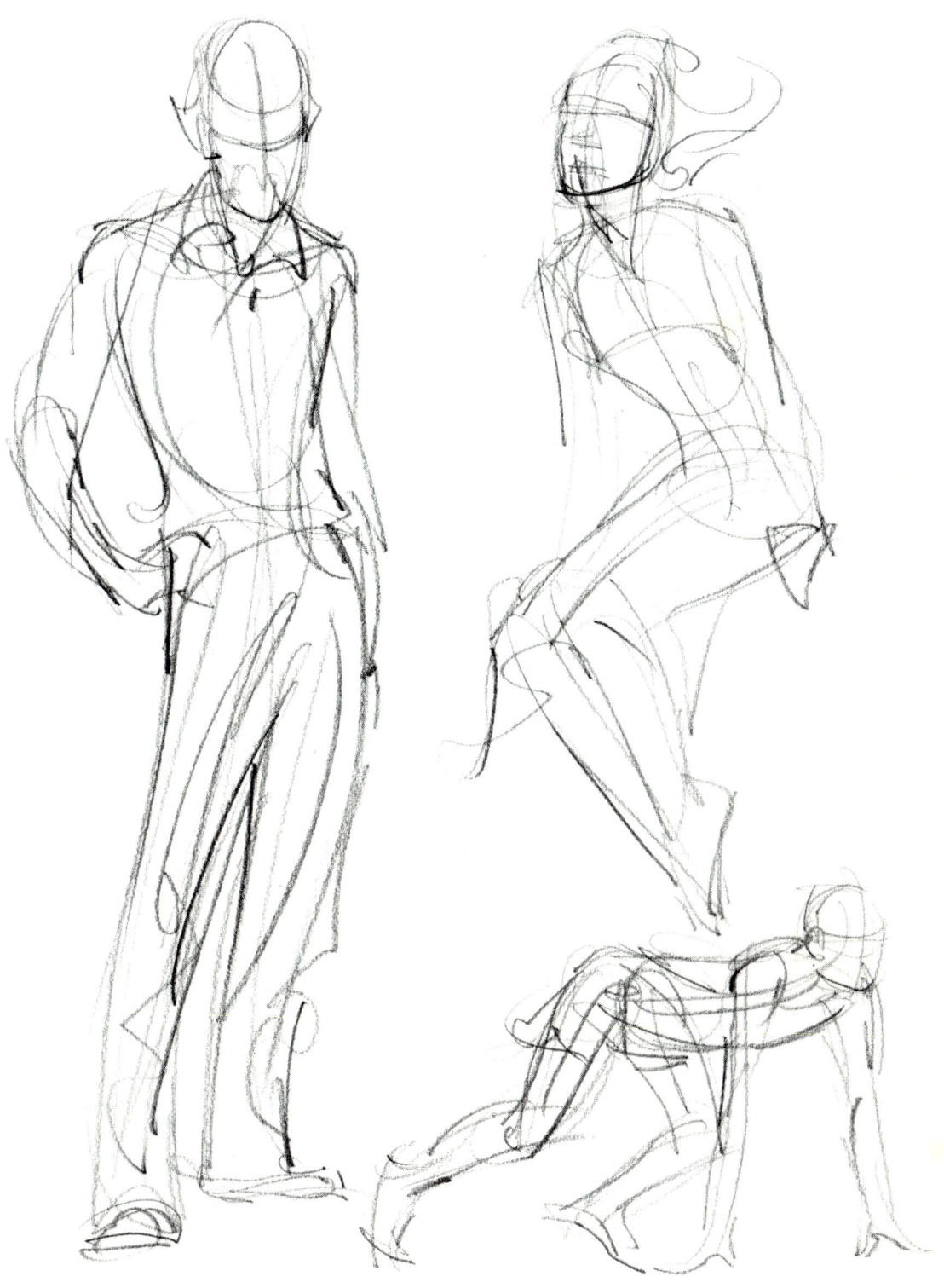

(23)

BLOCKING-IN SKETCHES

Another quickie warm-up exercise is the blocking-in sketch. This is done as quickly as the gesture sketch, but here we are trying to capture the mass or weight of the figure. By using dark areas for heavy parts of the body, such as the chest and thighs, and lighter areas for arms, fingers, legs, and toes, we can suggest weight differences on a flat piece of paper. We want our drawing to look as heavy or as light as the person who is posing.

In doing these sketches, pay special attention to whether the figure looks balanced. It shouldn't look as if it were falling over. As you sketch, ask yourself: if you were in the same position as the figure in your drawing, would you feel comfortable?

Try to capture the spirit of the pose. If the drawing is not perfect, you can change it later on.

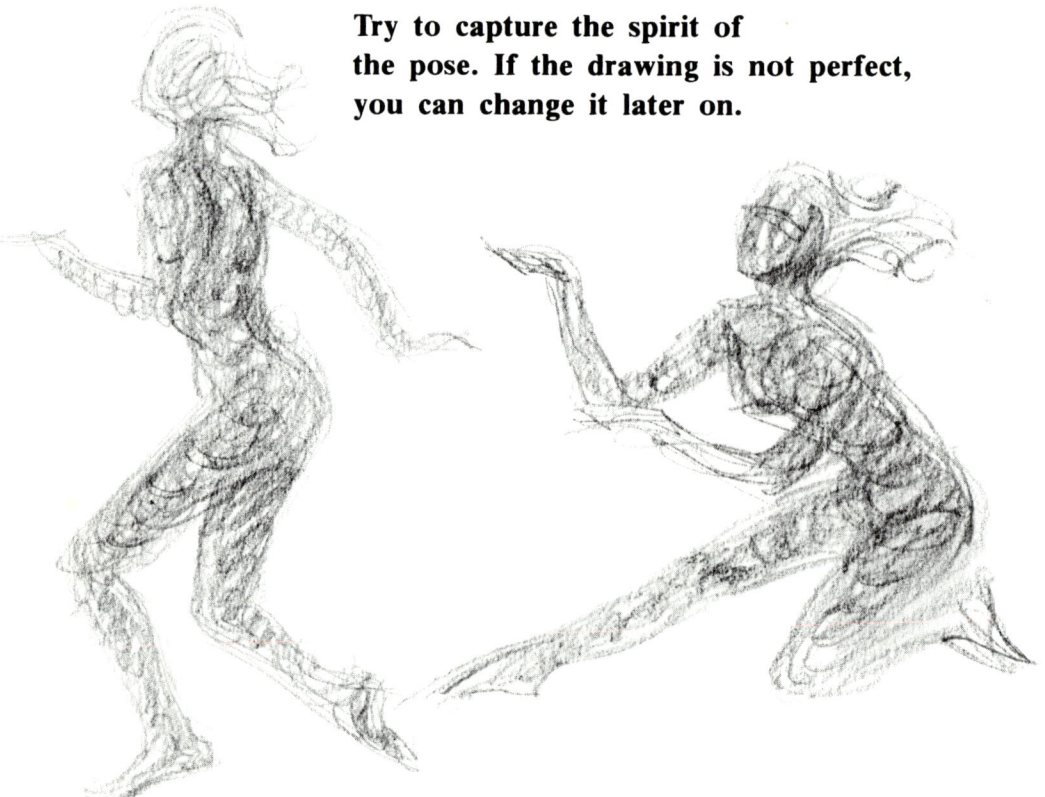

Don't put in detail.
Keep these drawings simple. Notice
the rhythm and movement here.

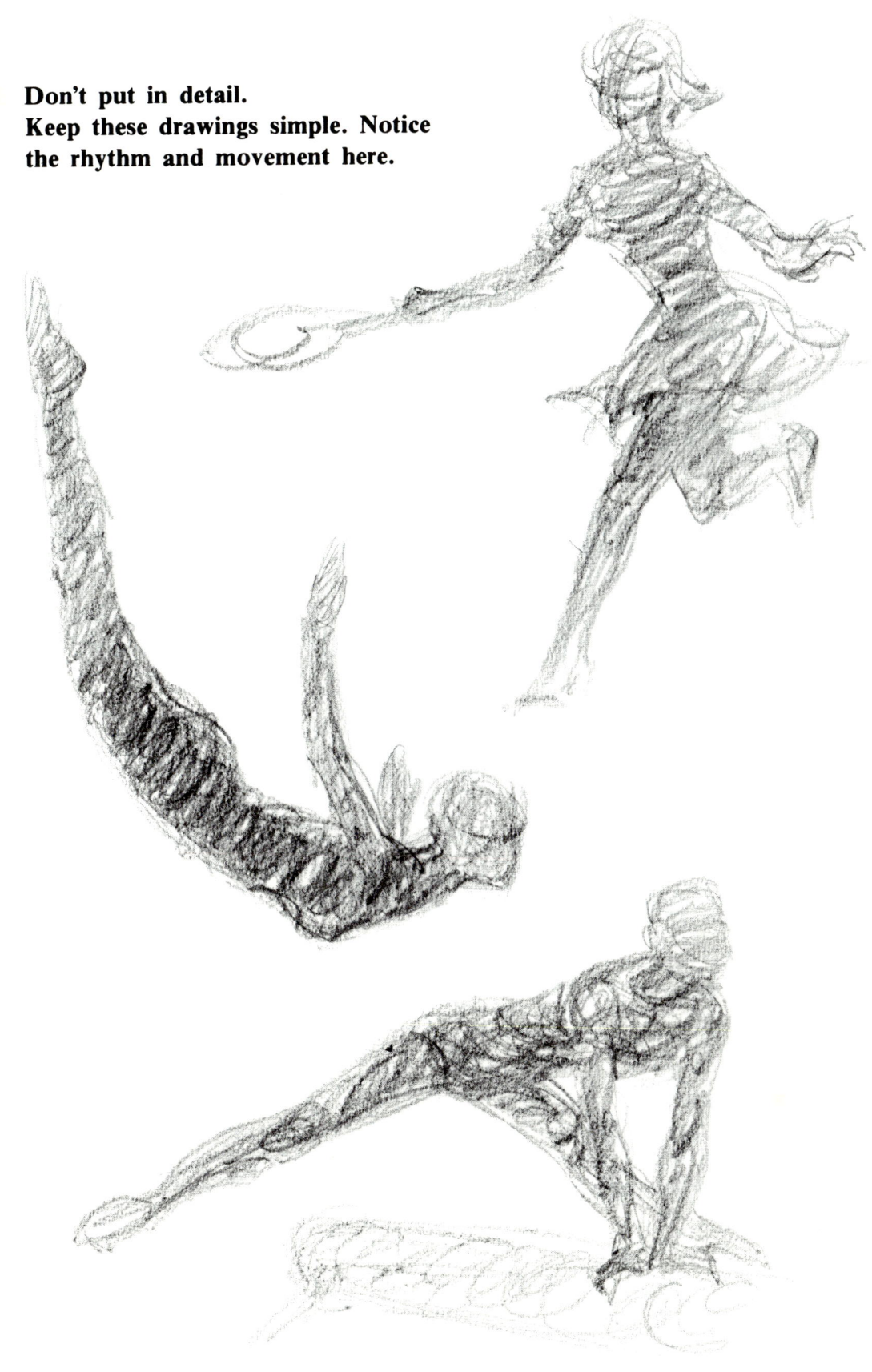

OUTLINE SKETCHES

Our third type of sketch is not really a warm-up. It should be complete in itself. Here we want to draw a line around the outside edge of the model. This line separates the model from the background and gives it form on paper. As you draw this line it should get thicker and darker in some places, and thinner and lighter in others, as in the example shown. This helps to give dimension to the form.

Draw the line as if you were touching the outside of the model. Look mostly at the model and try to "feel" what's happening with the pencil line. Where the form curves, press harder, and as it straightens out, use less pressure. This makes the line lighter or darker and makes the shape more realistic. You must work slower on this type of sketch than on the two previous ones.

See how the weight (blackness) of the line adds dimension here. Developing a sensitive "touch" with the pencil is what we're after. Keep your lines free-flowing and graceful. Your hand should feel relaxed and in control.

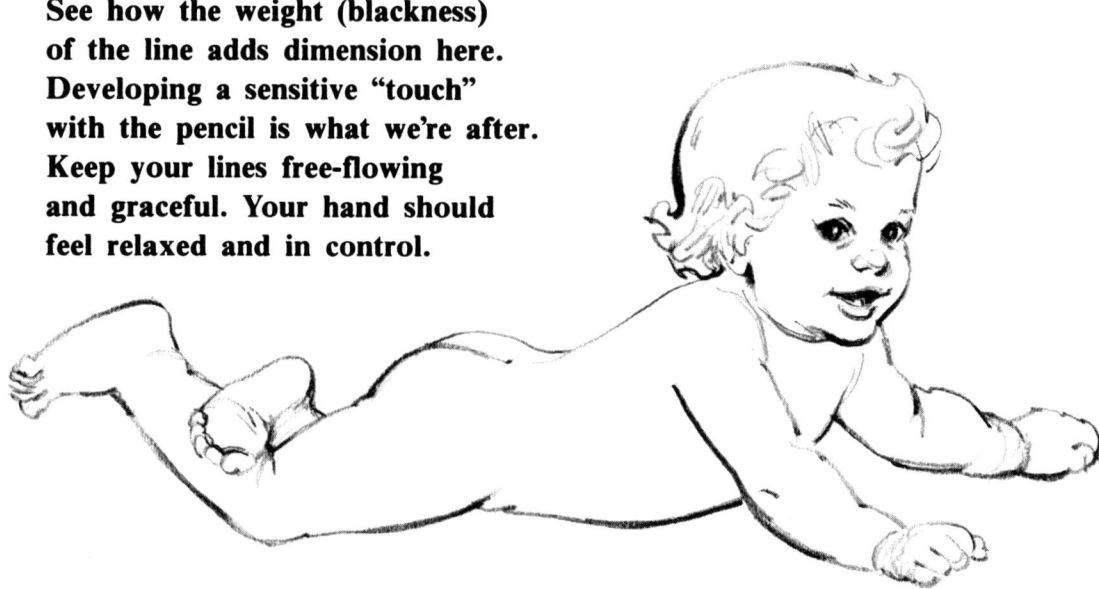

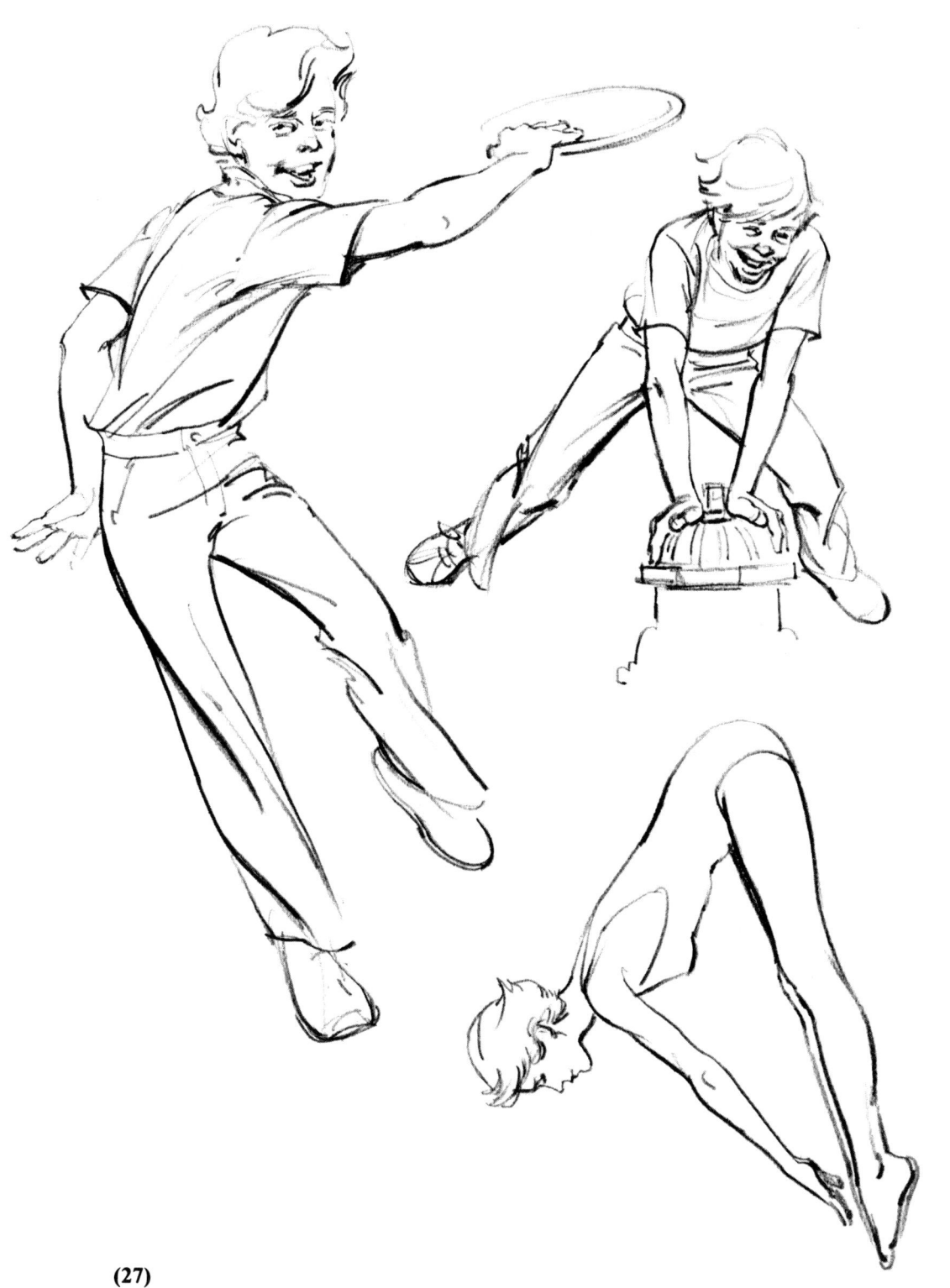

(27)

CROSS-CONTOUR SKETCHES

The fourth kind of sketch is designed to show one entire side of the body in three dimensions. We use lines like the outline sketch, except that each part of the body has many lines to describe its form. Draw slowly and try to include as much detail as you can, using the examples as a guide.

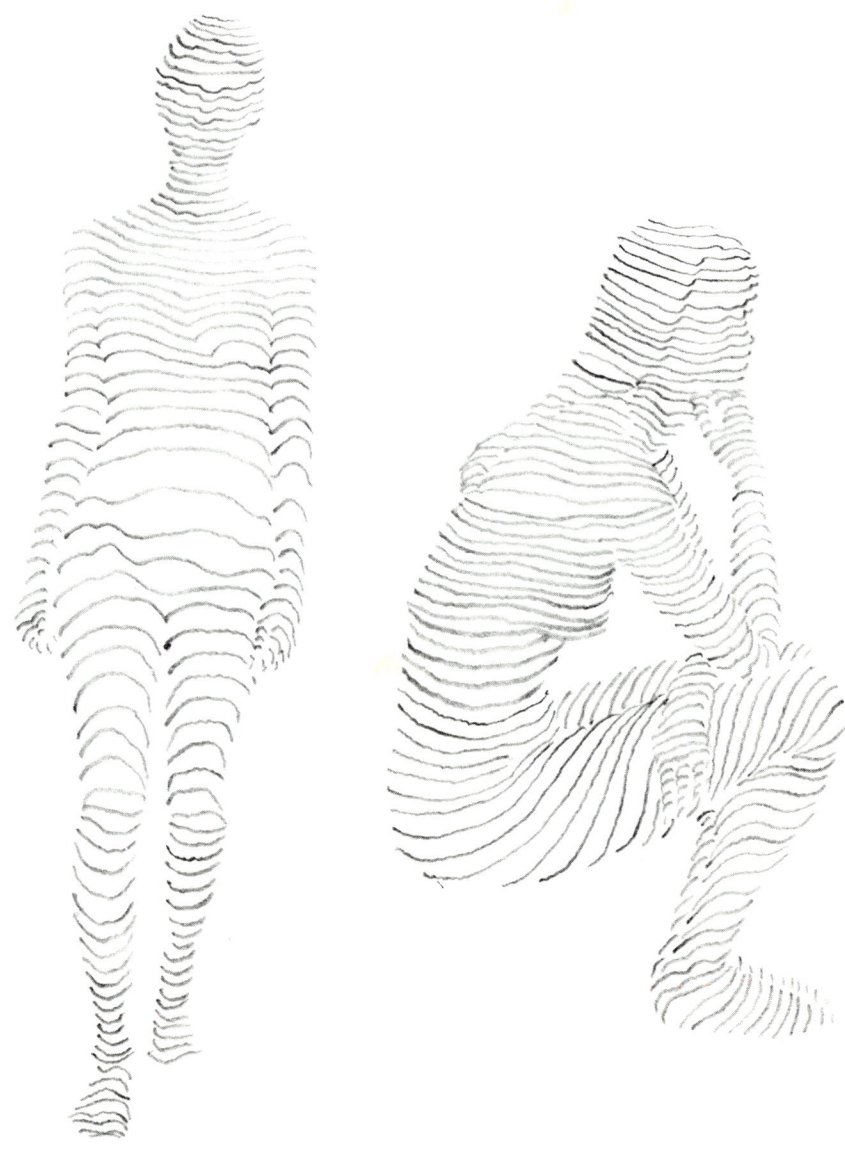

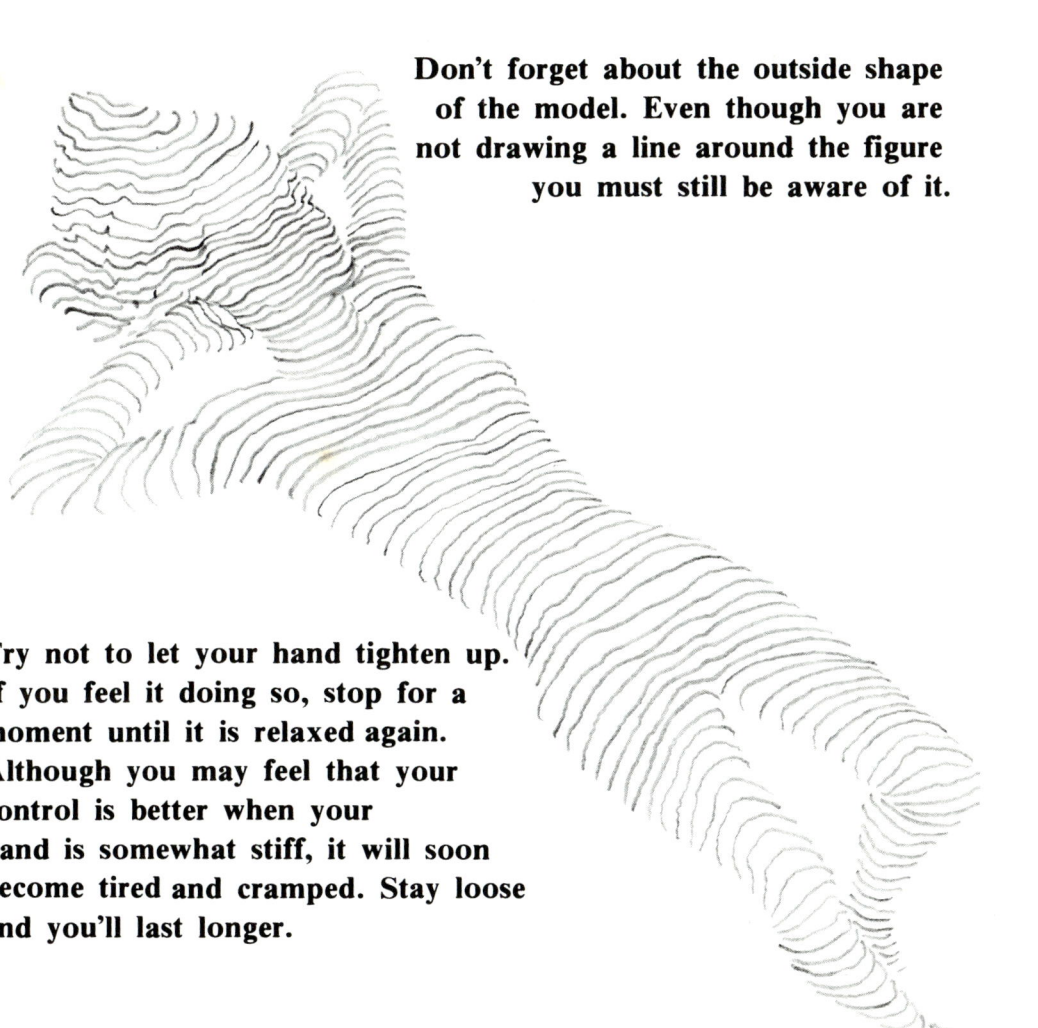

Don't forget about the outside shape of the model. Even though you are not drawing a line around the figure you must still be aware of it.

Try not to let your hand tighten up. If you feel it doing so, stop for a moment until it is relaxed again. Although you may feel that your control is better when your hand is somewhat stiff, it will soon become tired and cramped. Stay loose and you'll last longer.

Do as many of these sketches as you can. The outline and cross-contour sketches will help you see like an artist. The gesture and blocking-in sketches will help you draw like one. Remember not to work too long on any of these drawings. They are not meant to be finished works of art. That will come later. For now, try to have fun doing them, and do them as often as possible.

(29)

STICK FIGURE SKETCHES

Another excellent technique for the beginning drawer is "fleshing out" a stick figure. Begin by drawing a simple stick figure as in the example. Now build it up step-by-step. Add bulk around the arms and legs, chest, neck, and so on. Now add clothes and facial features.

Always start out with a very light pencil line. You won't want to use a strong black line until you're sure you have the figure exactly right.

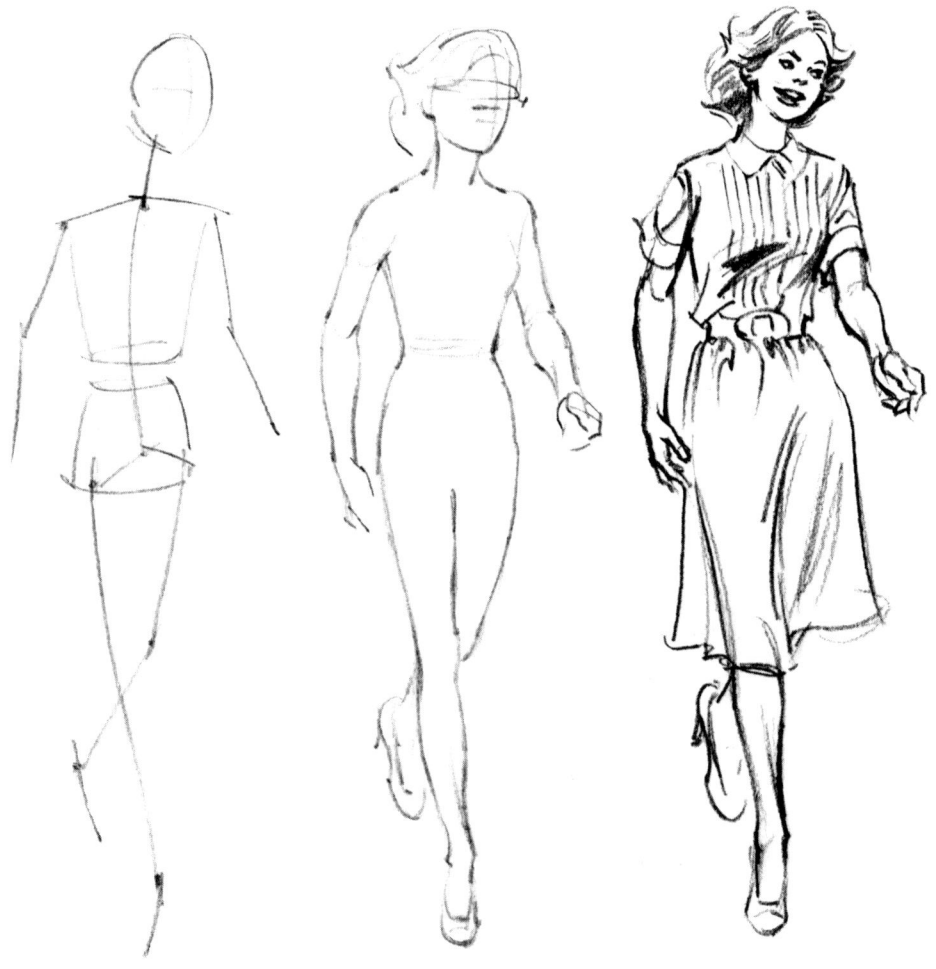

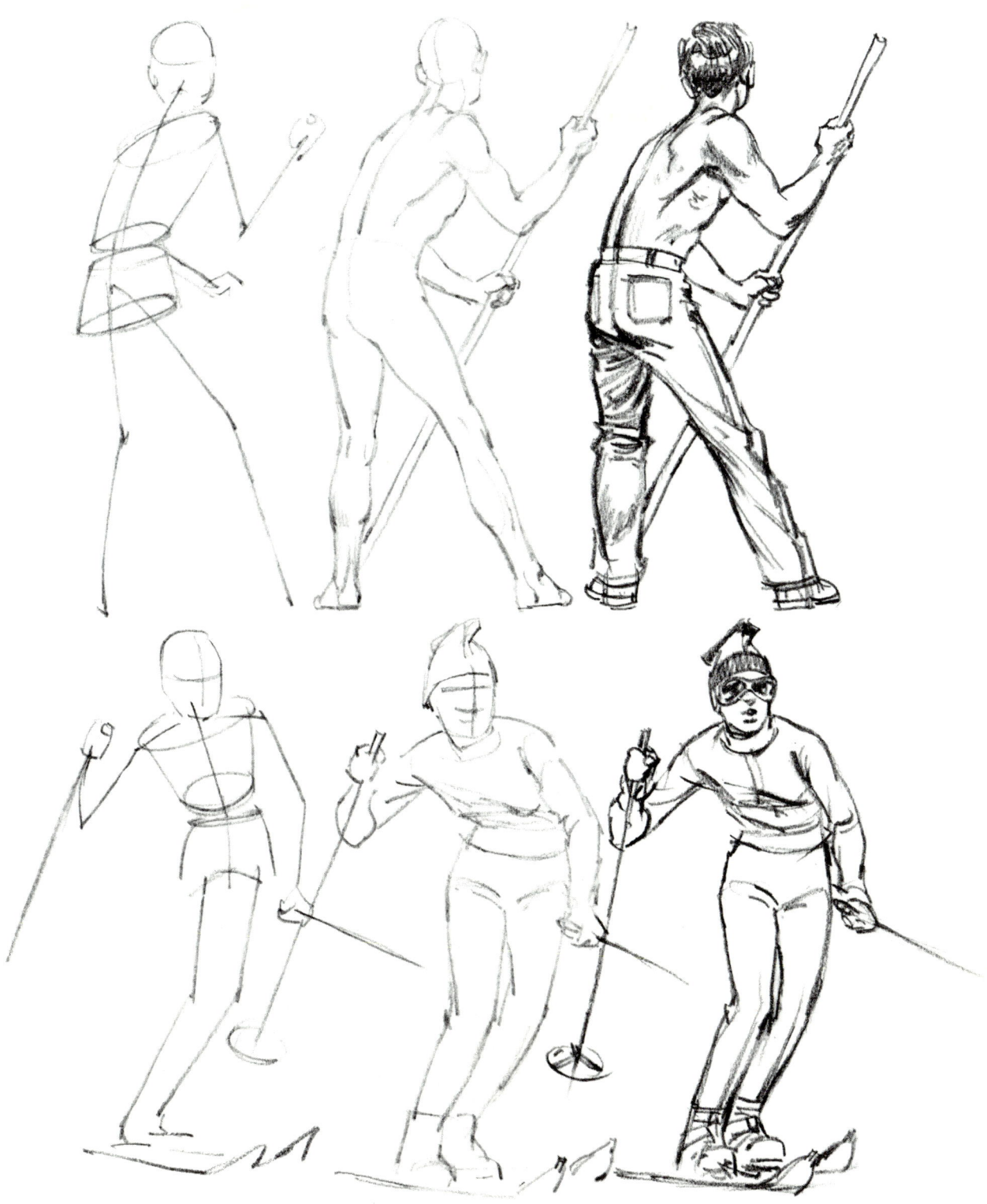

(31)

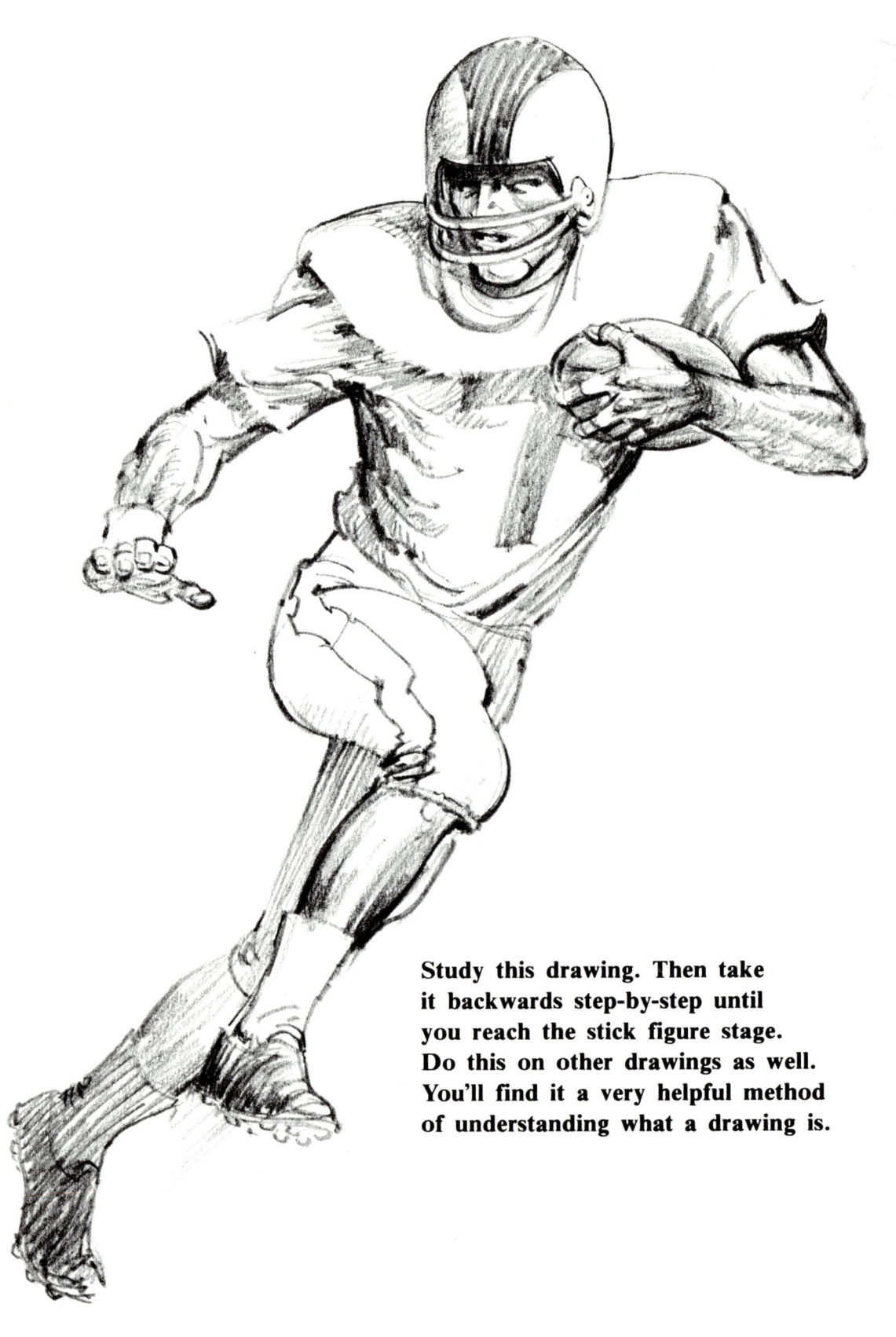

Study this drawing. Then take it backwards step-by-step until you reach the stick figure stage. Do this on other drawings as well. You'll find it a very helpful method of understanding what a drawing is.

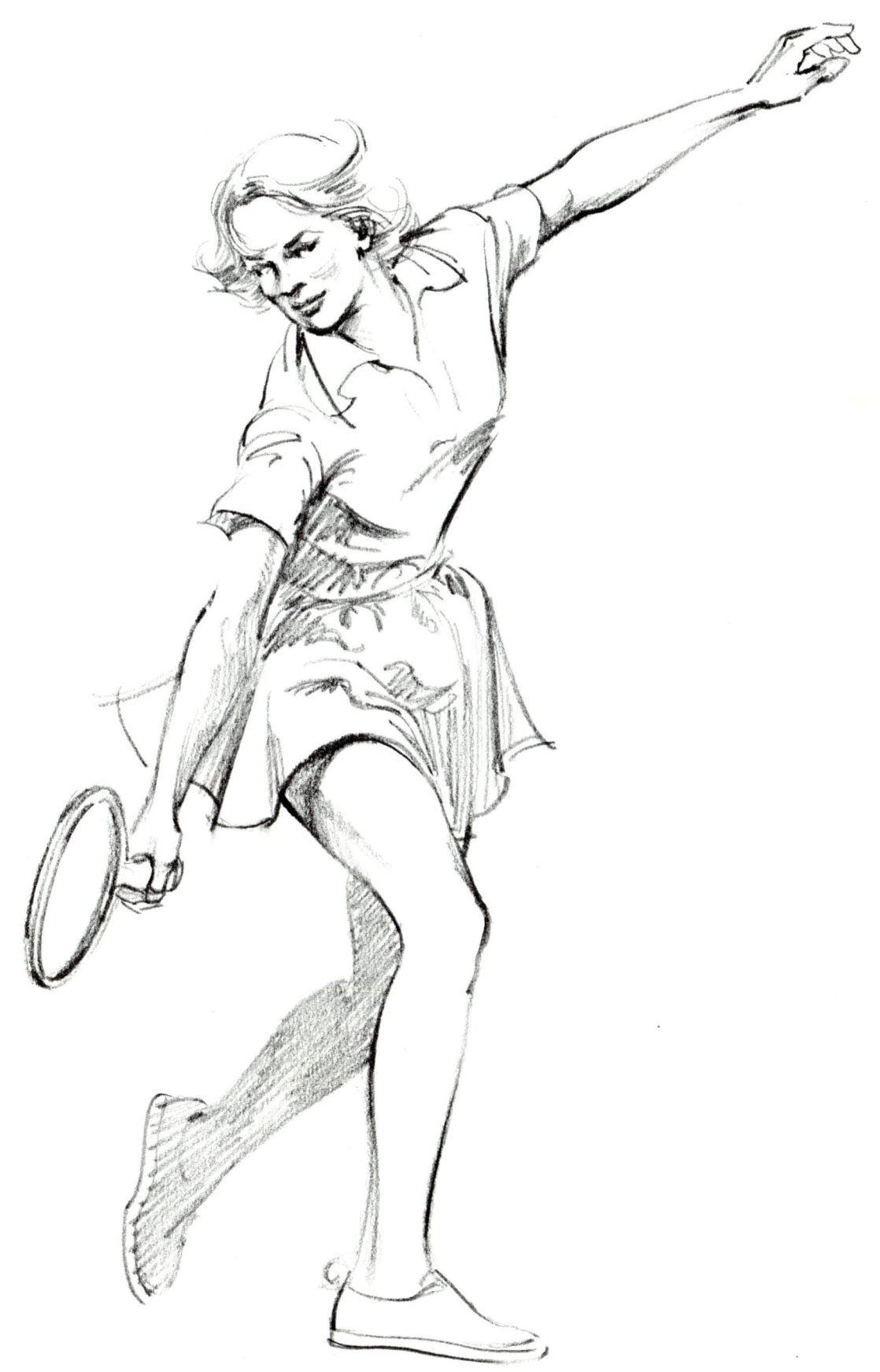

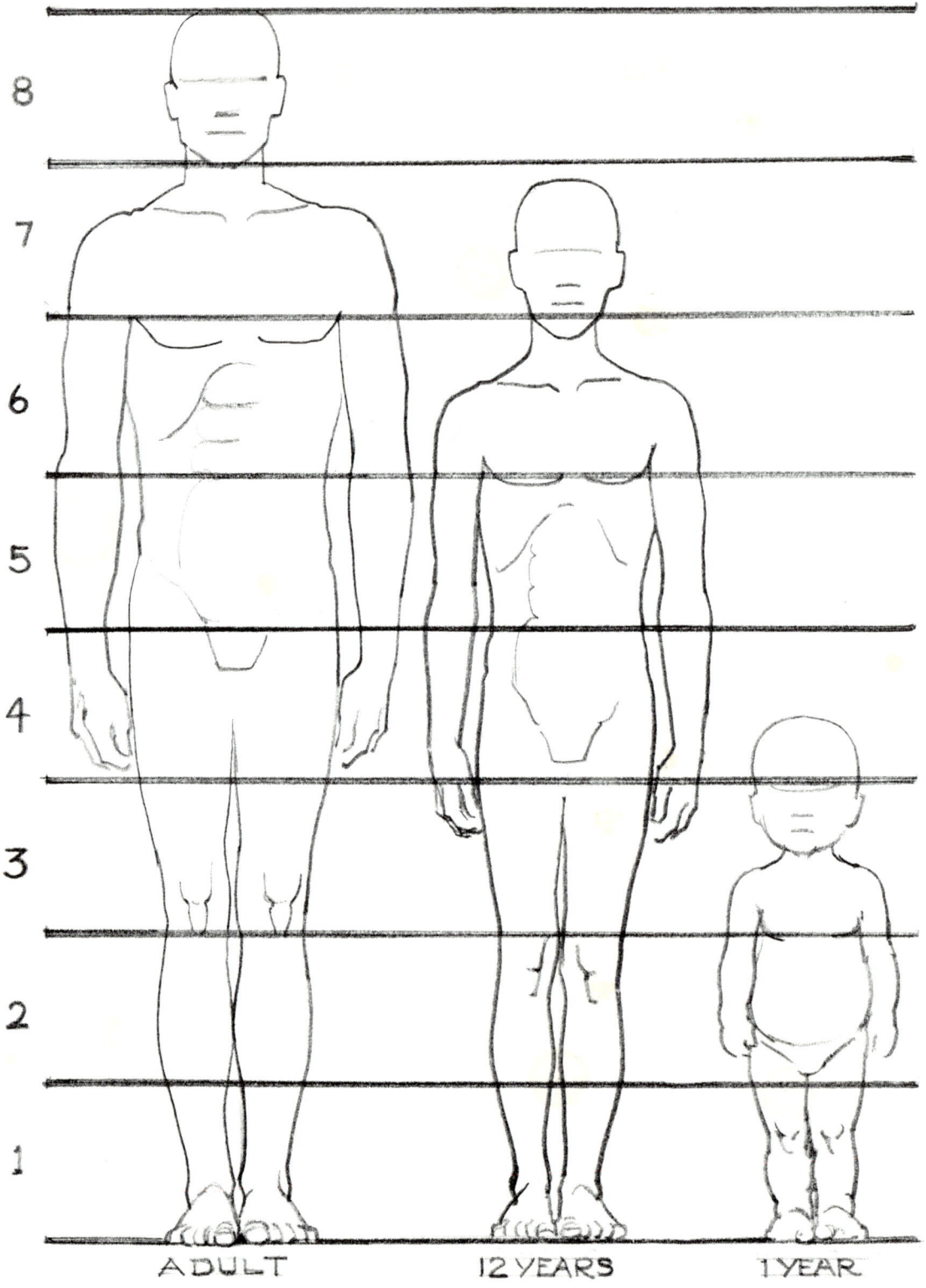

8

7

6

5

4

3

2

1

ADULT 12 YEARS 1 YEAR

Chapter 4
Basic Human Anatomy

As mentioned earlier, people are all pretty much the same. Some are short, some are tall, some are fat, some are thin. But human bodies are all still constructed pretty much the same, especially when it comes to proportions. For example, a male of fourteen years or older is usually eight heads tall. This means that if you pile eight of a particular man's head one on top of another, you will find that the height of the pile is just about the height of the man.

For any question you have concerning the nature of the human body, first see how *your* body is. It's more similar to others than you may think. Study your body and compare. The more information you have about the body, the easier it will be for you to draw it correctly. But remember: in drawing we are trying to capture feelings as well as images. If we spend too much time planning and figuring, we may lose some of that feeling.

(35)

All people are made up of bones, muscles, and skin. The bones form the basic structure. They determine the shape of the person. The muscles hold the bones together and enable the person to move. The skin keeps everything inside. Even though we see only the skin, for drawing we must become familiar with what the bones and muscles look like, too.

Try to locate the various bones in your body. Which ones move when you sit down or when you stand up?

Put your hand on your upper arm and lift a book from the table. Which muscles in your arm tighten up? Which go flabby? Try to feel which muscles bulge out when others relax. Now feel your wrist. Now your ankles and neck. Learn how everything works. Keep studying. You'll be amazed at the complexity of your own body and how much better your drawings will look when you understand it more.

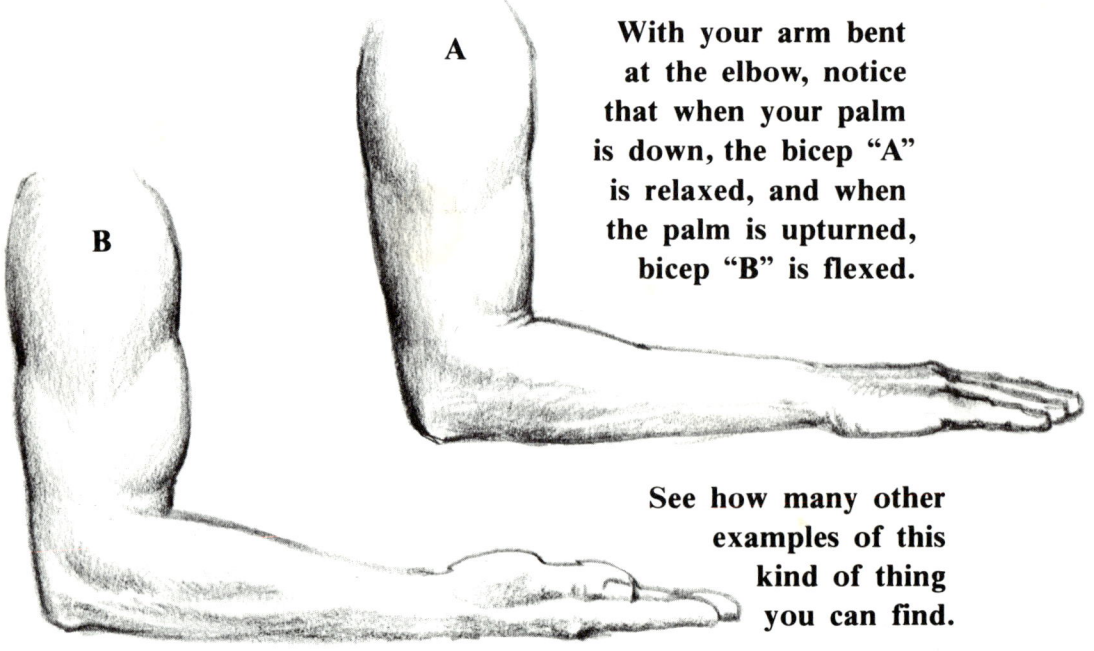

With your arm bent at the elbow, notice that when your palm is down, the bicep "A" is relaxed, and when the palm is upturned, bicep "B" is flexed.

See how many other examples of this kind of thing you can find.

(A) Here are a few rules of proportion that may be useful to you until you become more experienced. These are to be used as *guides only,* as the human form is almost as varied as the human race. Place a figure standing eight heads tall, with arms outstretched, in a square. Draw lines as shown, and you have the middle of the standard figure.

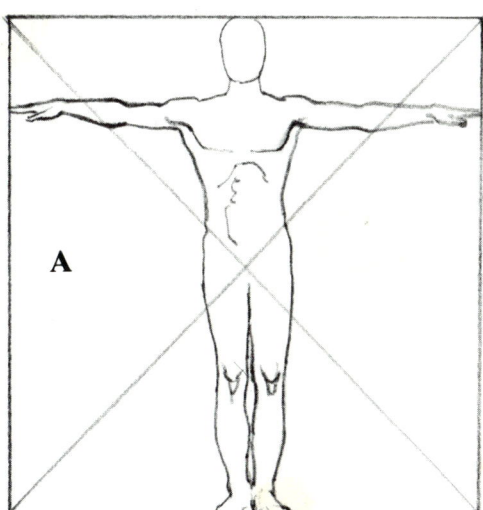

(B) The average figure, when seated, becomes two heads shorter. Also note that each section of the figure on the left is about two-and-one-half heads.

(C) Let's suppose a man and a woman are of equal height. Even so, there are some small but important differences. The man's neck is shorter, his chest is thicker, and his breast is higher. Also, the male torso is generally shorter. This in turn makes the legs longer. These are rules that nature constantly breaks, but use them until proportion is not a problem for you.

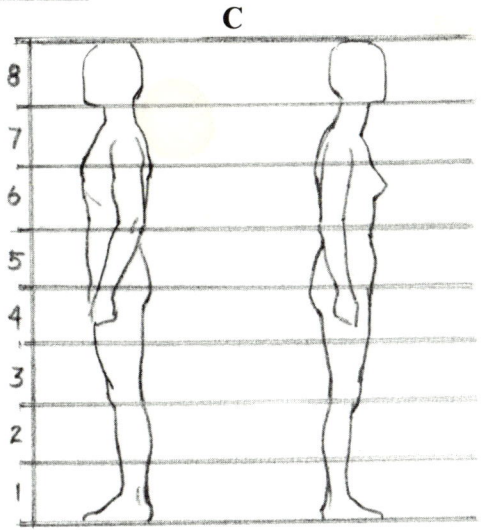

(37)

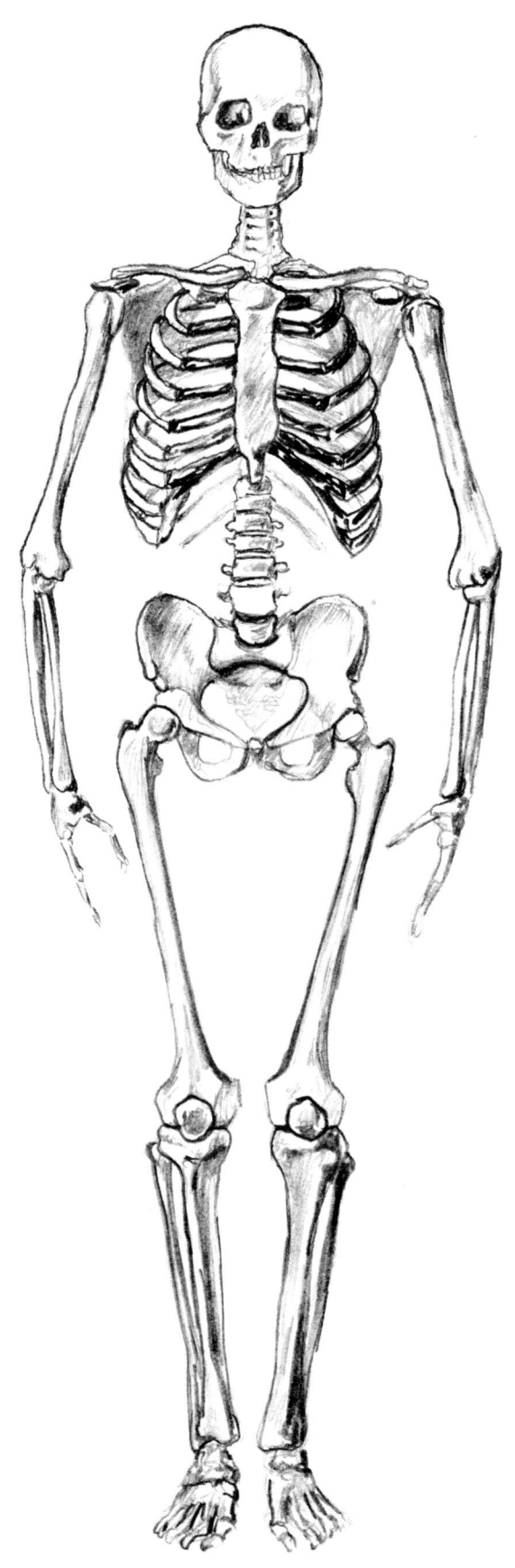

(38)

Chapter 5
The Parts of the Body

Our bodies are very wonderful and complicated organisms. In order for us to draw the human body properly, we must know more about it than just how it looks on the surface. We need to know something about what it's made of and how it works. For instance, although we cannot see them, without our bones we would be a shapeless mass of flesh, unable to move about and unrecognizable as human beings. Therefore, let us take a closer look at bones.

The bones, organized into a structure called the *skeleton*, provide a structure for the body. The skeleton gives the body its basic shape, allows us to stand erect, and helps us to perform all sorts of movements. The chief connector of the skeleton is the spine. It supports the two bone masses: the skull and the rib cage. The pelvis, a third bone mass, is suspended from the spine. The spine has a slight "S" curve to it so the three masses can rest directly above one another, with the line of gravity running directly down the middle. The bones of the leg extend from the pelvis, and the arm bones come from the clavicle, or collar bone.

Our muscles usually extend from one bone to another over and around a joint (a place where two bones meet). Thus they pull the bone as they contract, using the joint as a lever or pulley. Each muscle that pulls a bone has a complimentary muscle that can pull it in the opposite direction. Usually one will pull while the other relaxes.

Now let's examine some major parts of the body individually, head first.

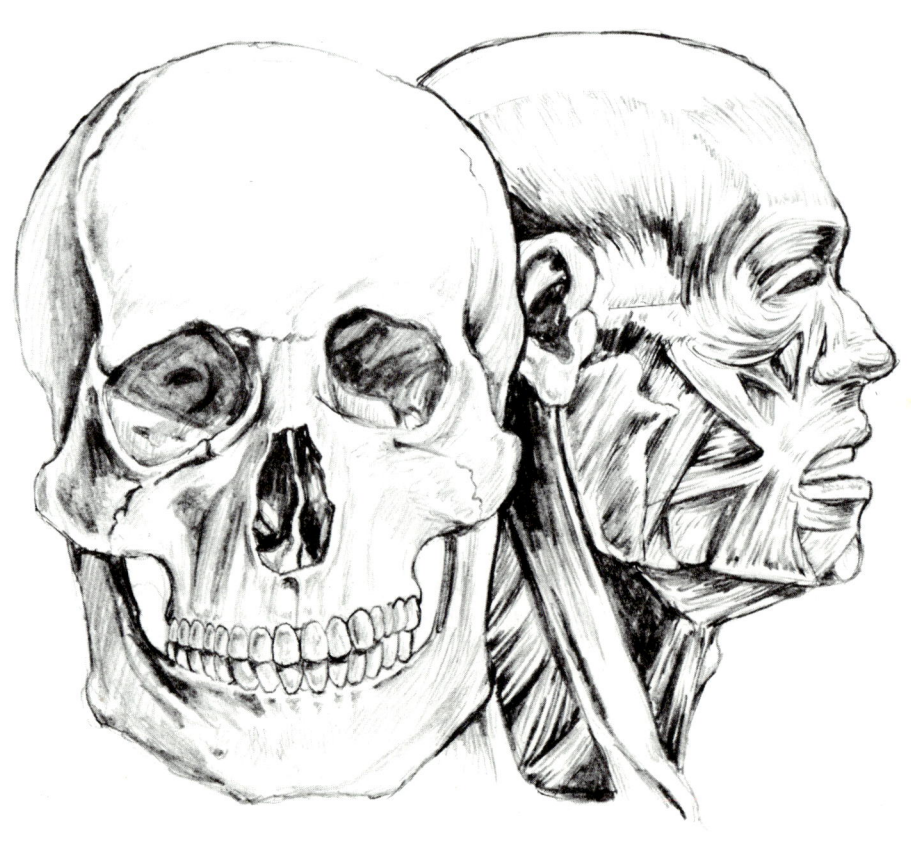

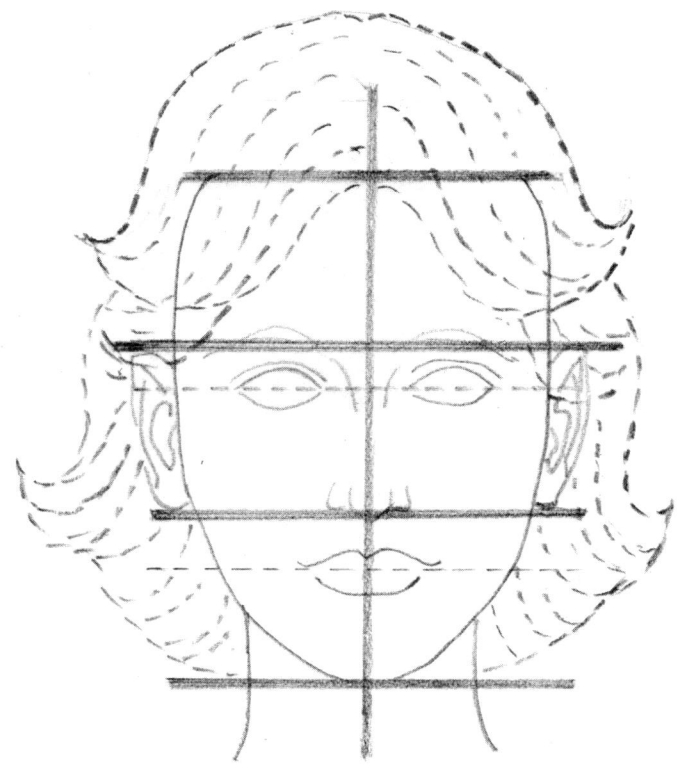

THE HEAD

In order to simplify things, think of the head as being composed of two basic shapes, a sphere or ball shape for the top of the head and an ovular or egg shape for the face. The head moves in two basic ways — from side to side on its axis on top of the spine and in a nodding manner, controlled by the neck muscles. The head is approximately one-eighth the height of the body.

Typically, the head is divided into thirds. From the top of the head to the brow is one third. From the brow to the tip of the nose is another third. And from the tip of the nose to the chin is the final third. The width of the head at its widest part is approximately four-and-one-third "eyes." Or, more simply, once again the width from the middle of the nose to the end of the brow.

(41)

THE TORSO

The largest single mass of the body, the torso can be
thought of as having three sections: the rib cage, which
is a fairly rigid barrel shape; the stomach area, which is
very flexible; and the pelvis, again a rigid structure.

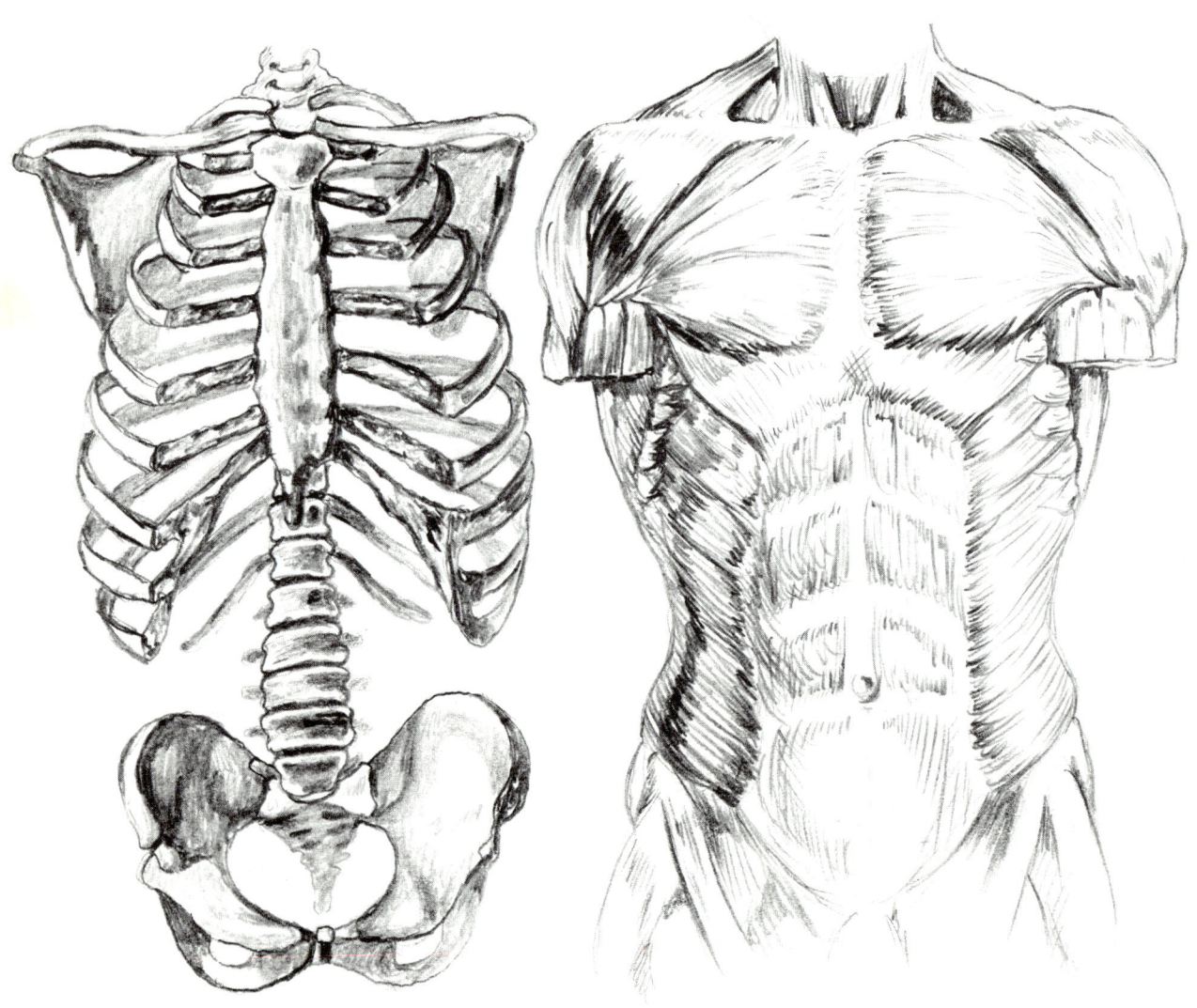

THE ARM

The upper arm contains one large bone. It starts at the shoulder and ends at the elbow — which is level with the waist. The lower arm has two bones, both of which

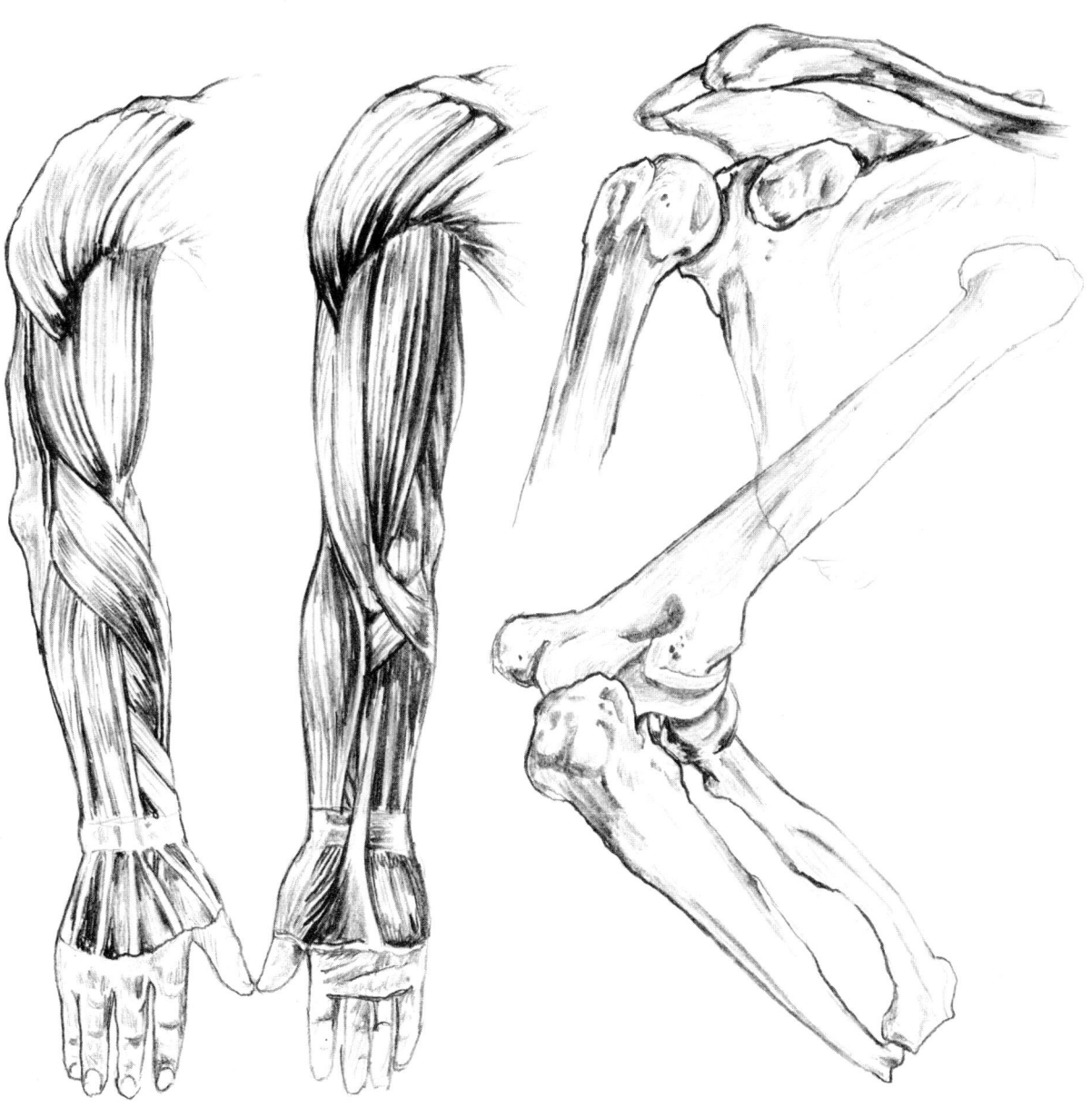

extend from the elbow to the wrist. The length of the entire arm from shoulder to fingertip ends at about mid-thigh.

The arm is capable of many complex movements. Think of the arm as being two cylinders, with the muscles creating different bulges according to how the arm is being used.

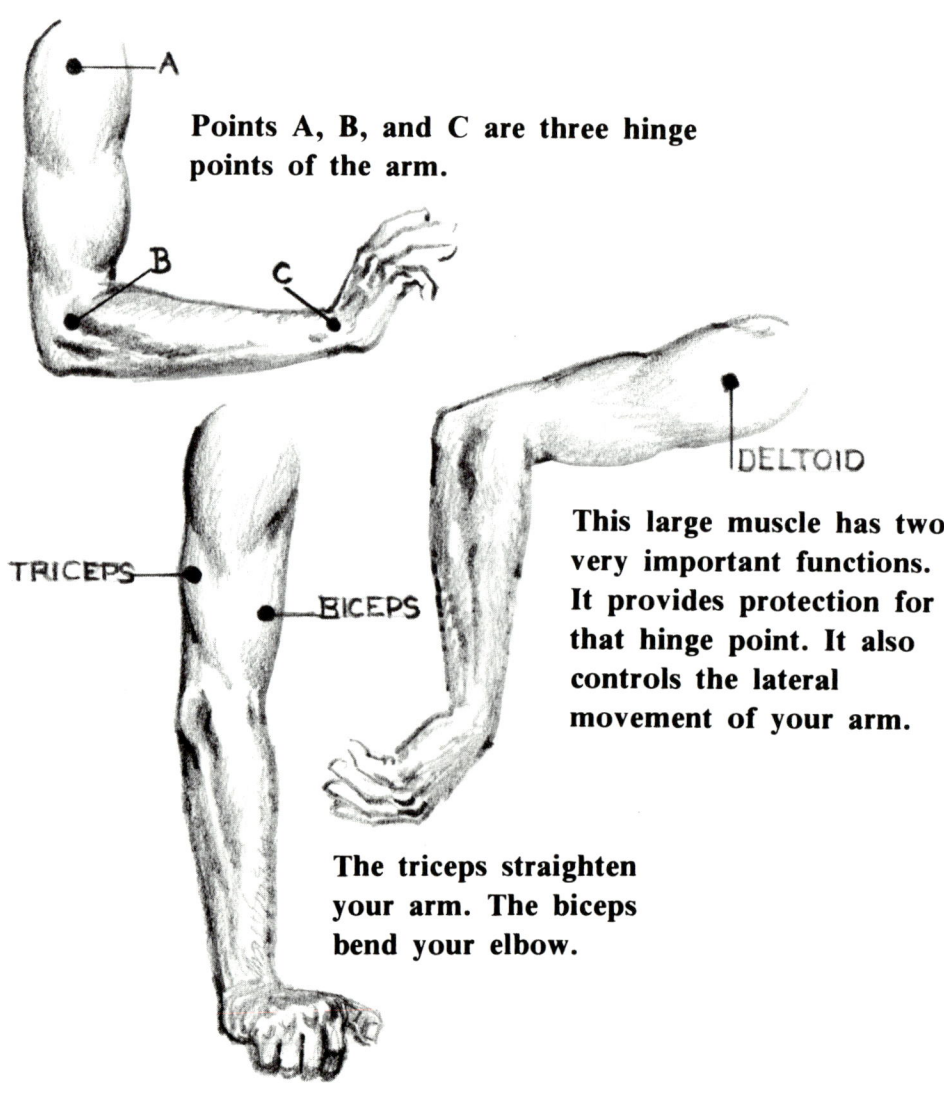

Points A, B, and C are three hinge points of the arm.

DELTOID

This large muscle has two very important functions. It provides protection for that hinge point. It also controls the lateral movement of your arm.

TRICEPS

BICEPS

The triceps straighten your arm. The biceps bend your elbow.

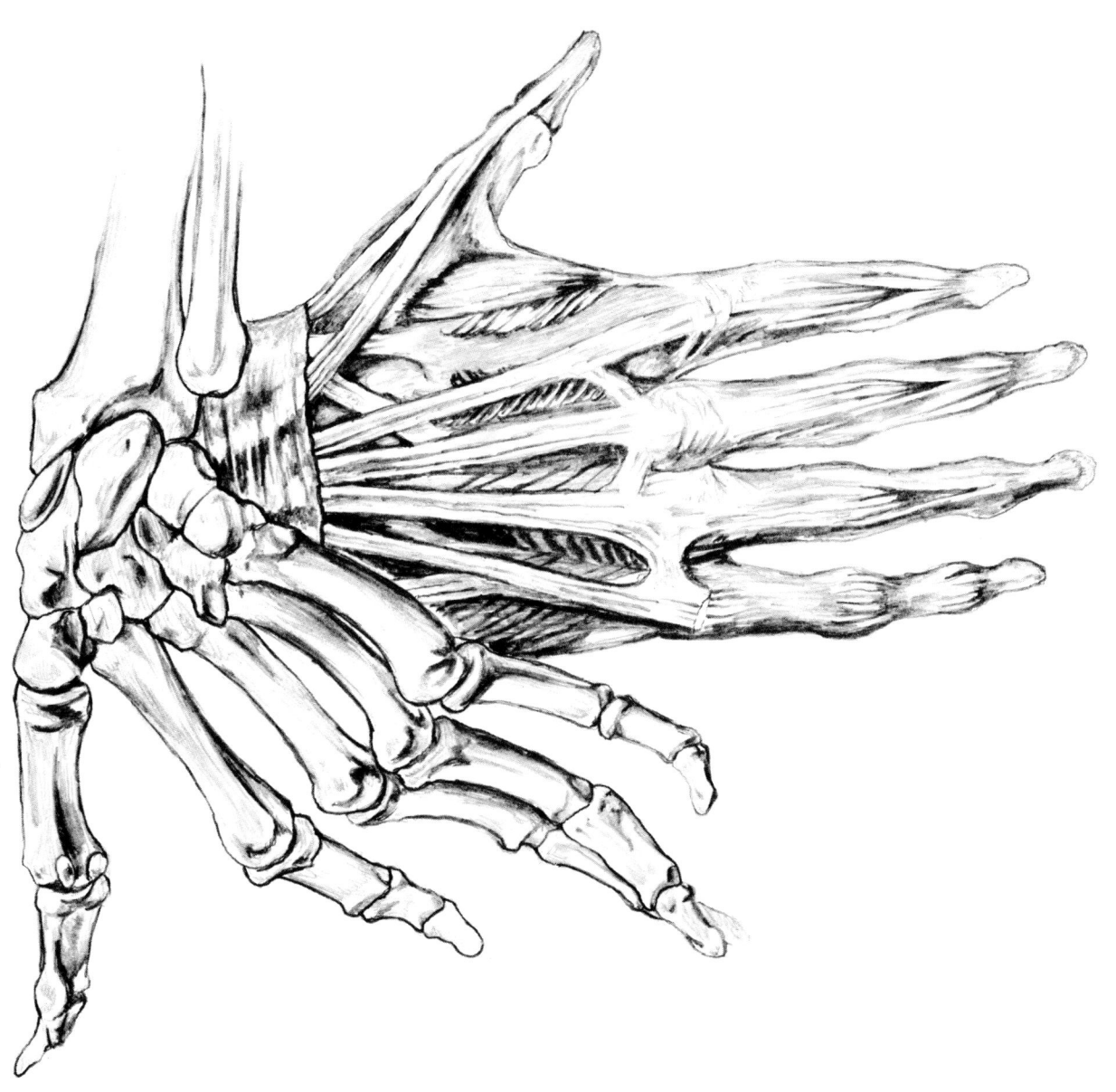

THE HAND

The hand's length is three-quarters that of the head, and its width is the distance from the nose to the chin. The middle, or largest finger, is equal to the length of the palm. The hand is the most expressive part of the body, next to the face. As a result, it is difficult to draw and will require much practice.

(45)

Because hands are difficult and can show the emotion of your subject almost as clearly as the face, they must be high on your list of things to master.

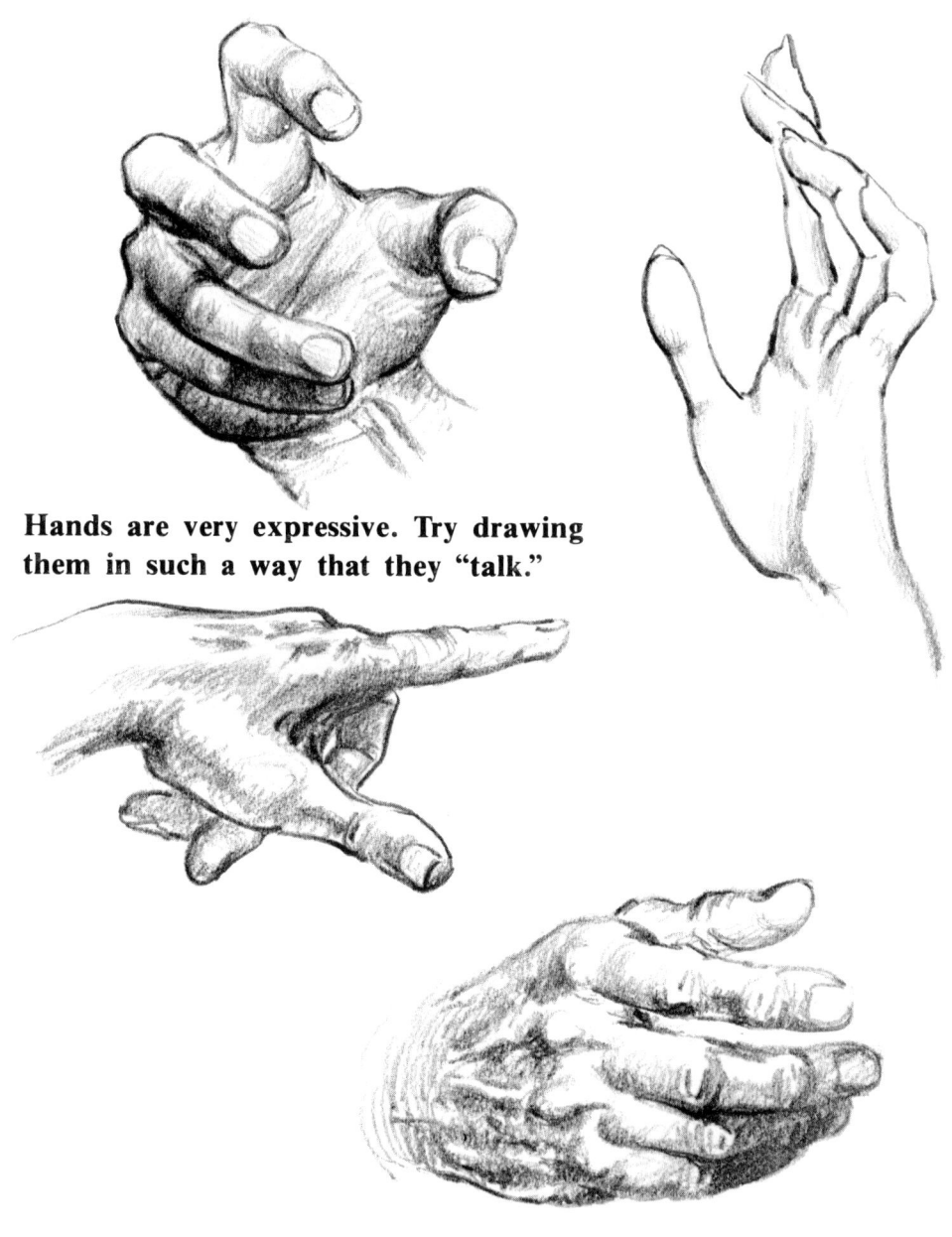

Hands are very expressive. Try drawing them in such a way that they "talk."

THE LEG

As with the arm, the upper leg has one bone and the lower has two. The thigh bone connects with the pelvis in a ball-and-socket joint that allows a great deal of movement. At the knee, movement is much more restricted.

The muscles of the leg start with the *gluteus maximus,* which is the part you sit down on. From there, the thigh muscles form a cylindrical shape slanting inward to the knee. The lower leg contains a rounded calf muscle, which tapers down to the ankle. Remember while drawing the legs that they support the rest of the body and must be firmly planted on the feet!

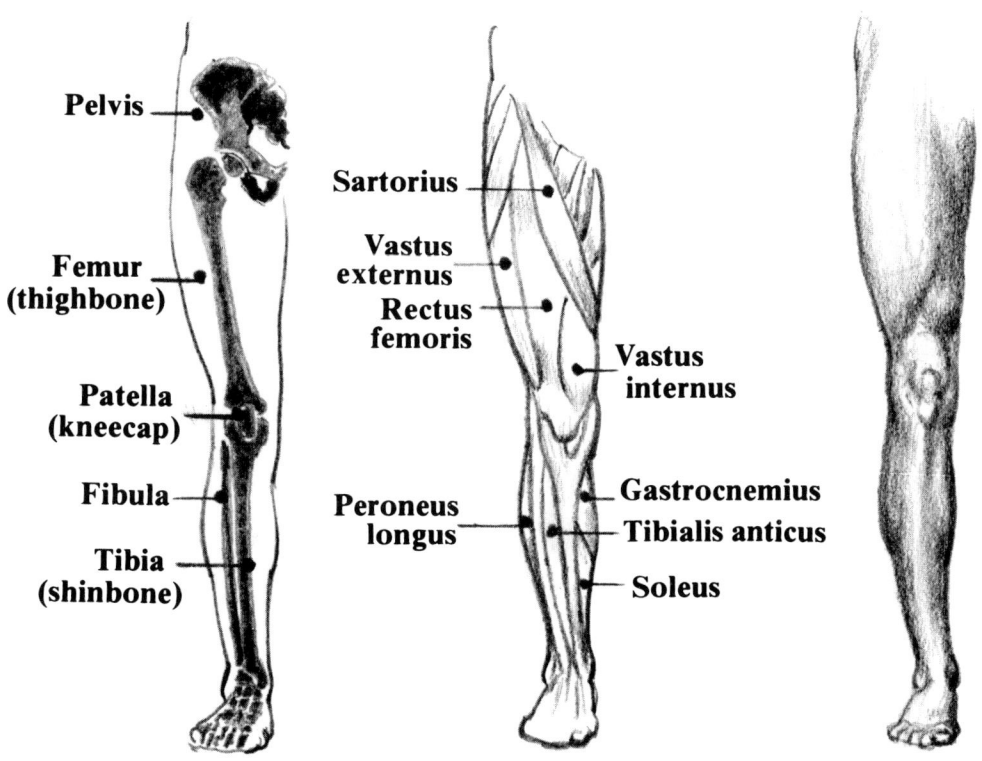

Pelvis

Femur
(thighbone)

Patella
(kneecap)

Fibula

Tibia
(shinbone)

Sartorius

Vastus
externus

Rectus
femoris

Vastus
internus

Peroneus
longus

Gastrocnemius

Tibialis anticus

Soleus

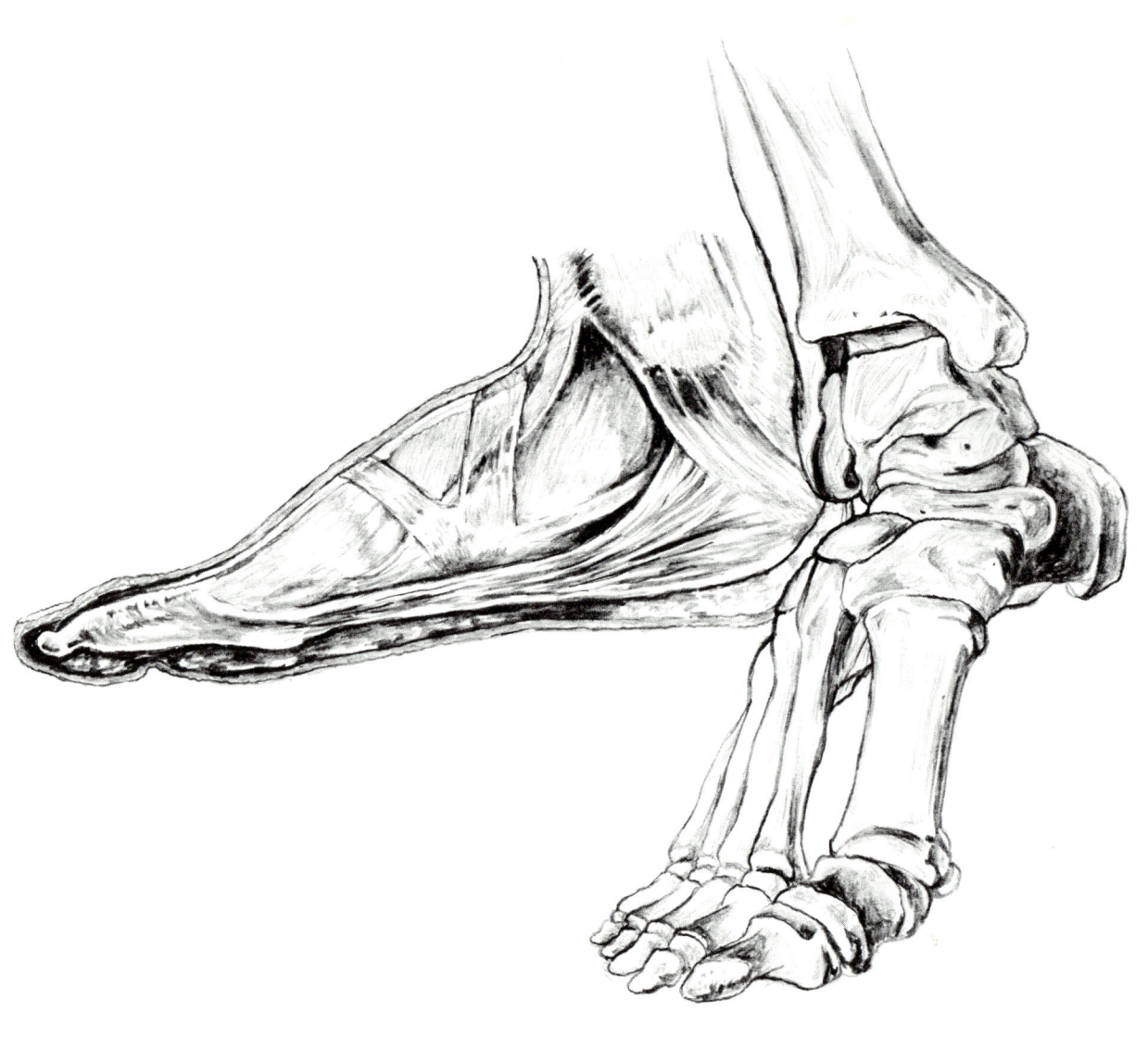

THE FOOT

In length, the foot is the same as the forearm, or about one-and-a-half heads. It is one-half a head wide. There are three major sections to the foot: the heel, the arch, and the frontal area, which includes the toes. The small toe ends on a line where the big toe begins.

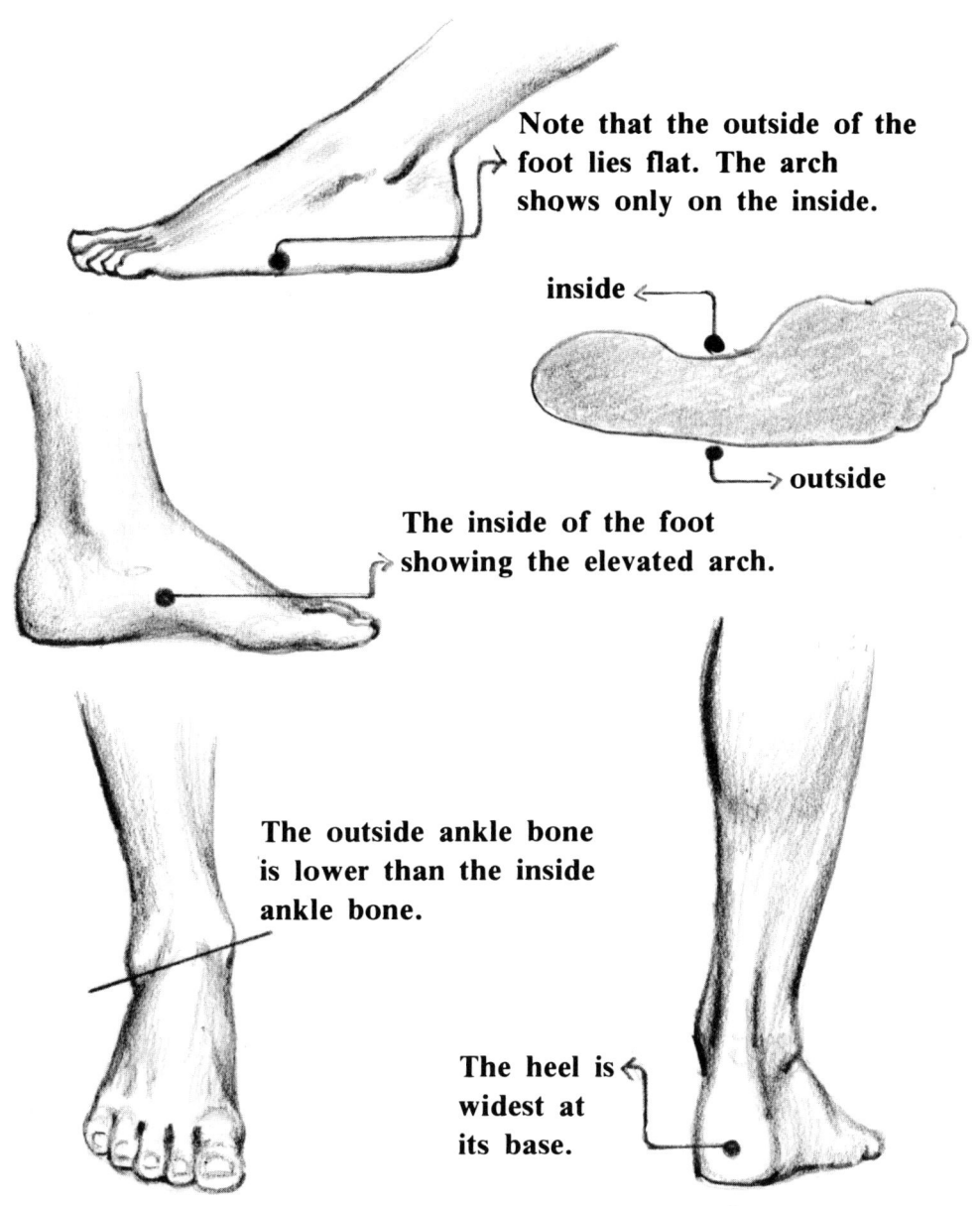

Note that the outside of the foot lies flat. The arch shows only on the inside.

inside ← → outside

The inside of the foot showing the elevated arch.

The outside ankle bone is lower than the inside ankle bone.

The heel is widest at its base.

One note before we continue. This section of the book is designed to be used as a guide. The measurements given are not exact, and your drawing does not have to match them perfectly. But if something is giving you trouble or doesn't quite look right, the way to fix it may be found here.

Now, with your new knowledge of anatomy, test what you feel you have learned. Use the sketches on these two pages as a guide, working from the bones out.

Using tracing paper, sketch a stick figure, then place tracing paper over that. Repeat for the skin layer, and if it is a clothed figure, a fourth overlay for the clothes.

Don't be discouraged with your first few efforts. You didn't learn to walk in just a few tries.

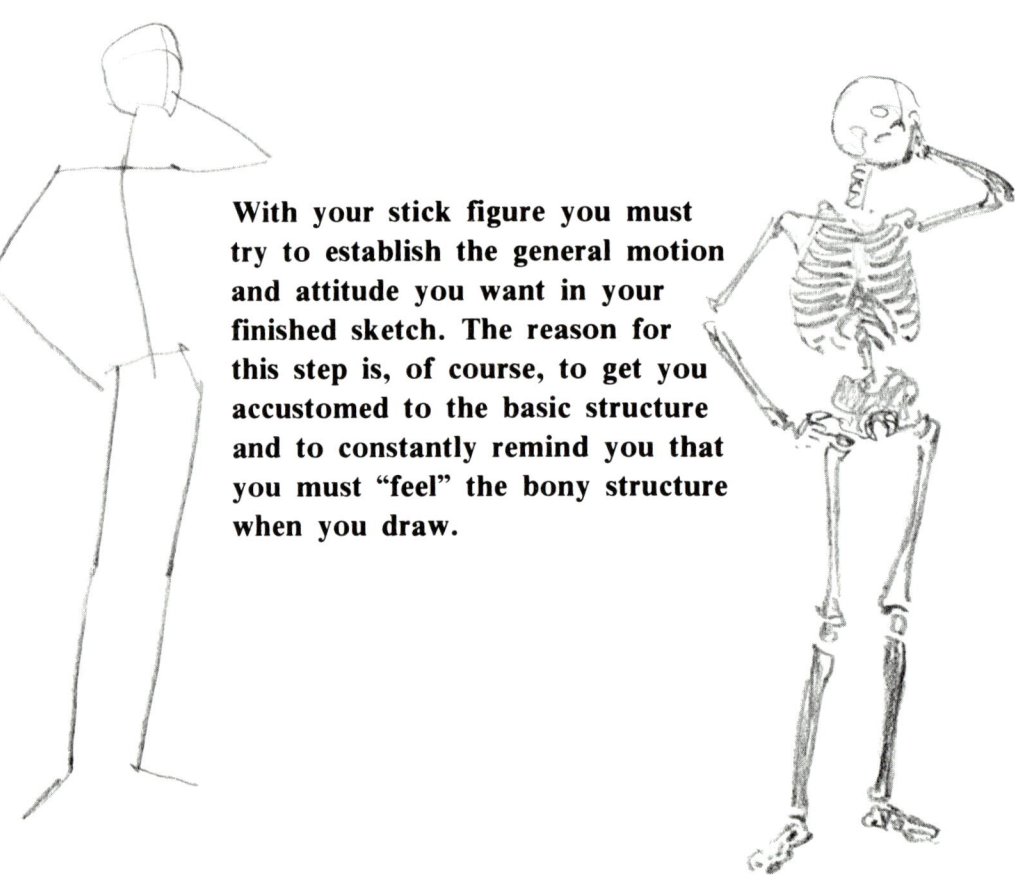

With your stick figure you must try to establish the general motion and attitude you want in your finished sketch. The reason for this step is, of course, to get you accustomed to the basic structure and to constantly remind you that you must "feel" the bony structure when you draw.

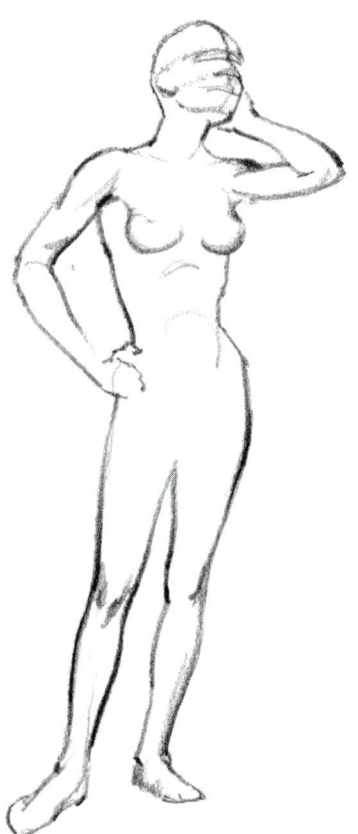

In this part of the "building" process, you should begin to work toward a feeling of roundness in all of your forms. Never think of your sketches as flat. What you think and feel are very, very important when you sketch.

In clothing your sketch, try to use a model so you can truly see how clothes follow the body, and how and why the forms underneath cause folds and wrinkles. Until you are quite experienced you can learn far more working from a model.

(51)

(52)

Chapter 6
Shading and Foreshortening

Go into a dark room with a mirror and a lighted candle. Hold the candle up to your face and look at the reflection in the mirror. Notice that the part of your face that is the closest to the light is the lightest. The parts furthest away are the darkest.

This is all you really need to know about shading. The parts of the object that are closest to the light source are lightest and get darker as they move further away or are blocked off from the light.

Study carefully how light and dark change what an object looks like. This is very important.

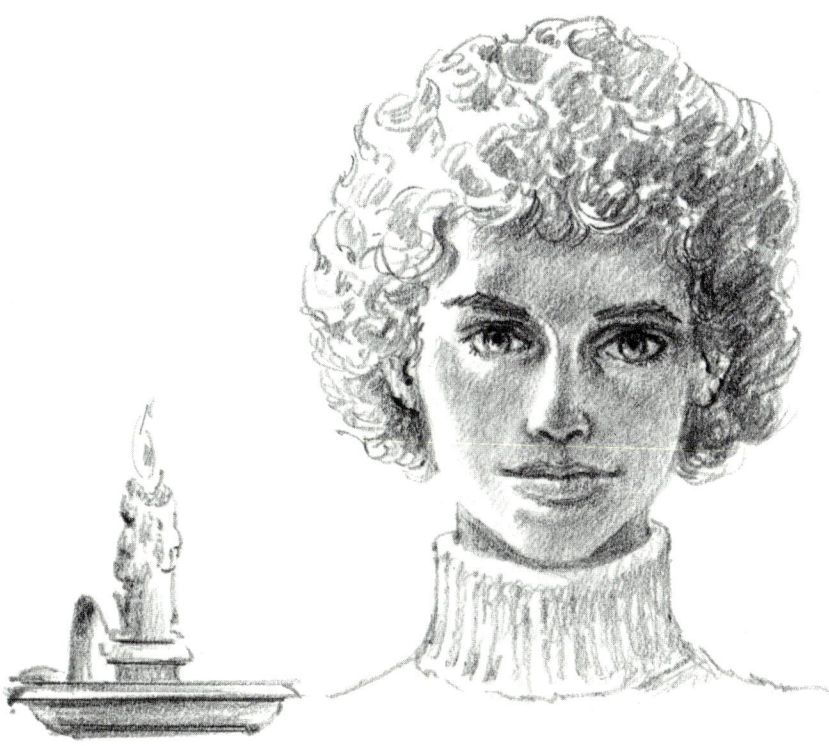

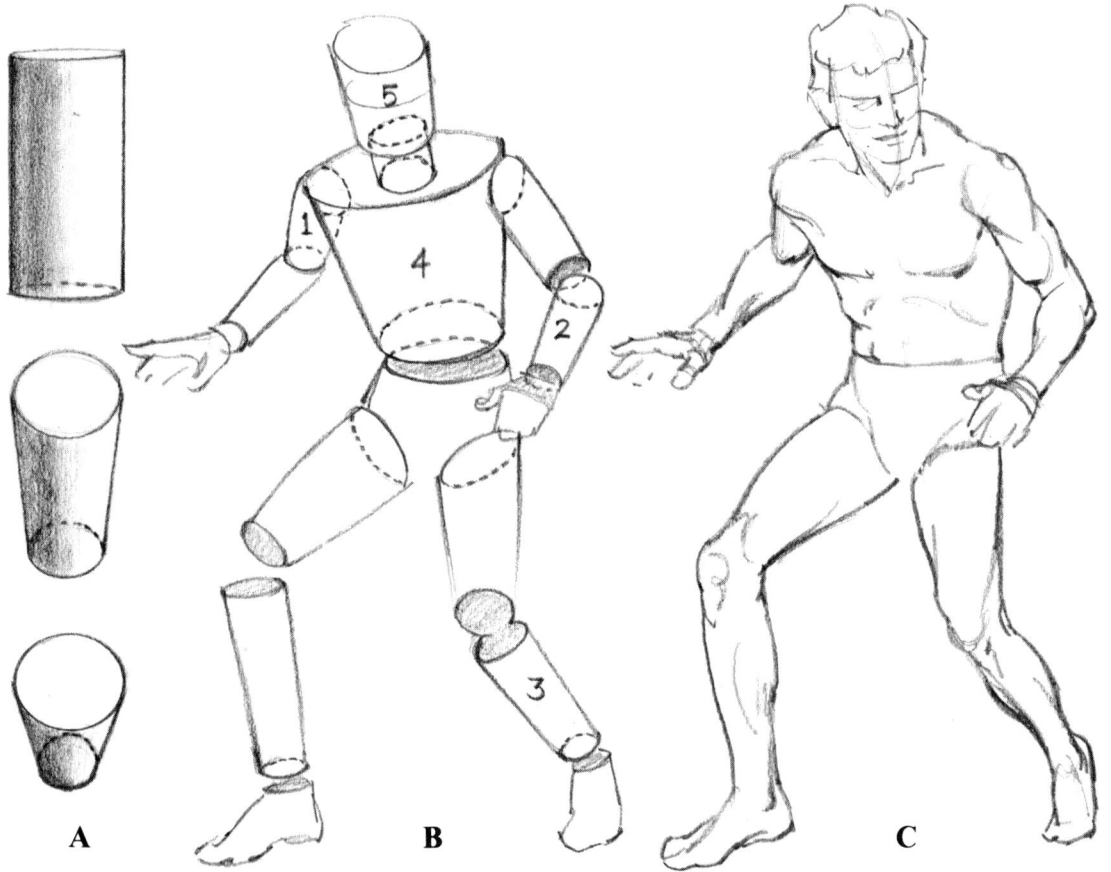

A B C

Foreshortening is what happens when one part of the body (or object) is markedly closer to you than the rest.

Sketch (A) shows what happens to the *appearance* of a simple cylinder when it undergoes foreshortening. The dotted lines indicate the unseen side.

Sketch (B) shows the body drawn with most of it shown as a series of cylinders. Those marked 1, 2, and 3 are the forms that are most visibly foreshortened, 4 and 5 are less so.

Note particularly the changes in proportion and shape in sketch (C). Sketch (C) is drawn more as a figure to show you how the cylinders can be the basis for a good sound sketch.

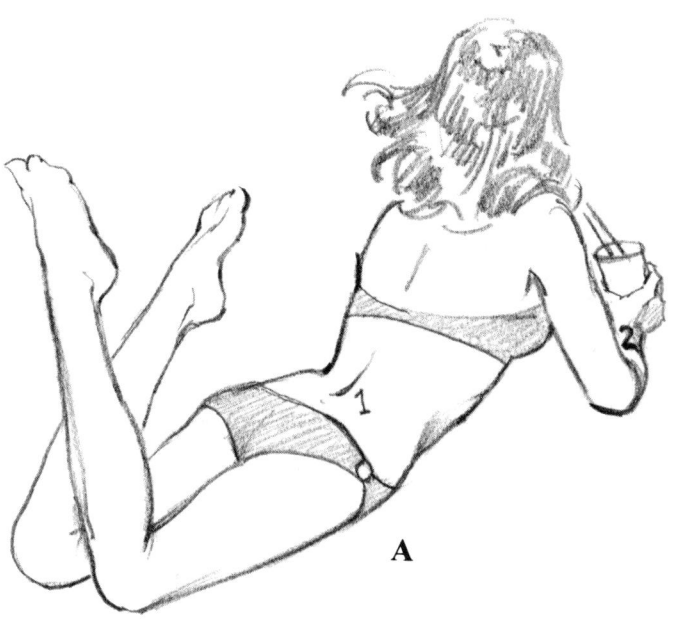

A

In both sketches (A) and (B), many
areas are foreshortened. However, in
sketch (A), the area marked 1, the
pelvic region, and the right forearm
and hand, 2, are very foreshortened.
In simpler terms, neither area is as
long as if seen in profile.

In sketch (B), areas 1, 2, and
3 are those most foreshortened and
will probably give you the most
difficulty when you work on this
problem. It would be wise to
use tracing paper overlays
on any troublesome areas in your
sketches, also using the cylinder
as a basic form to aid you in
any of your foreshortening
problems. It's most
important to think of
this as more of a
challenge than an obstacle.

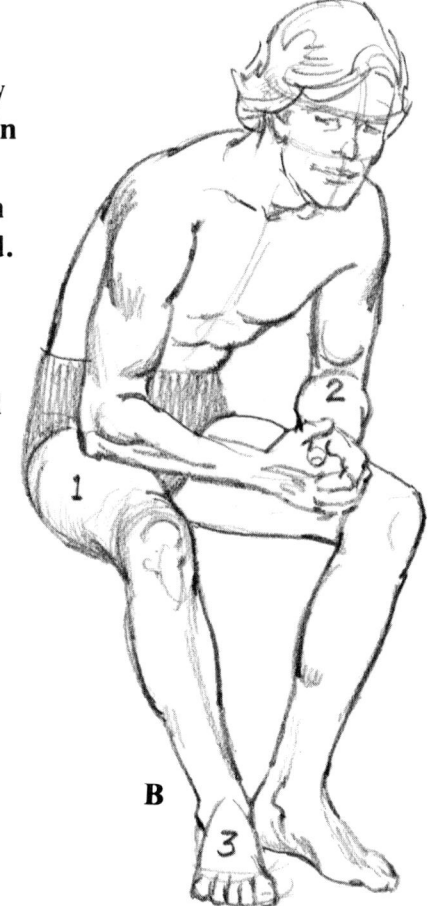

B

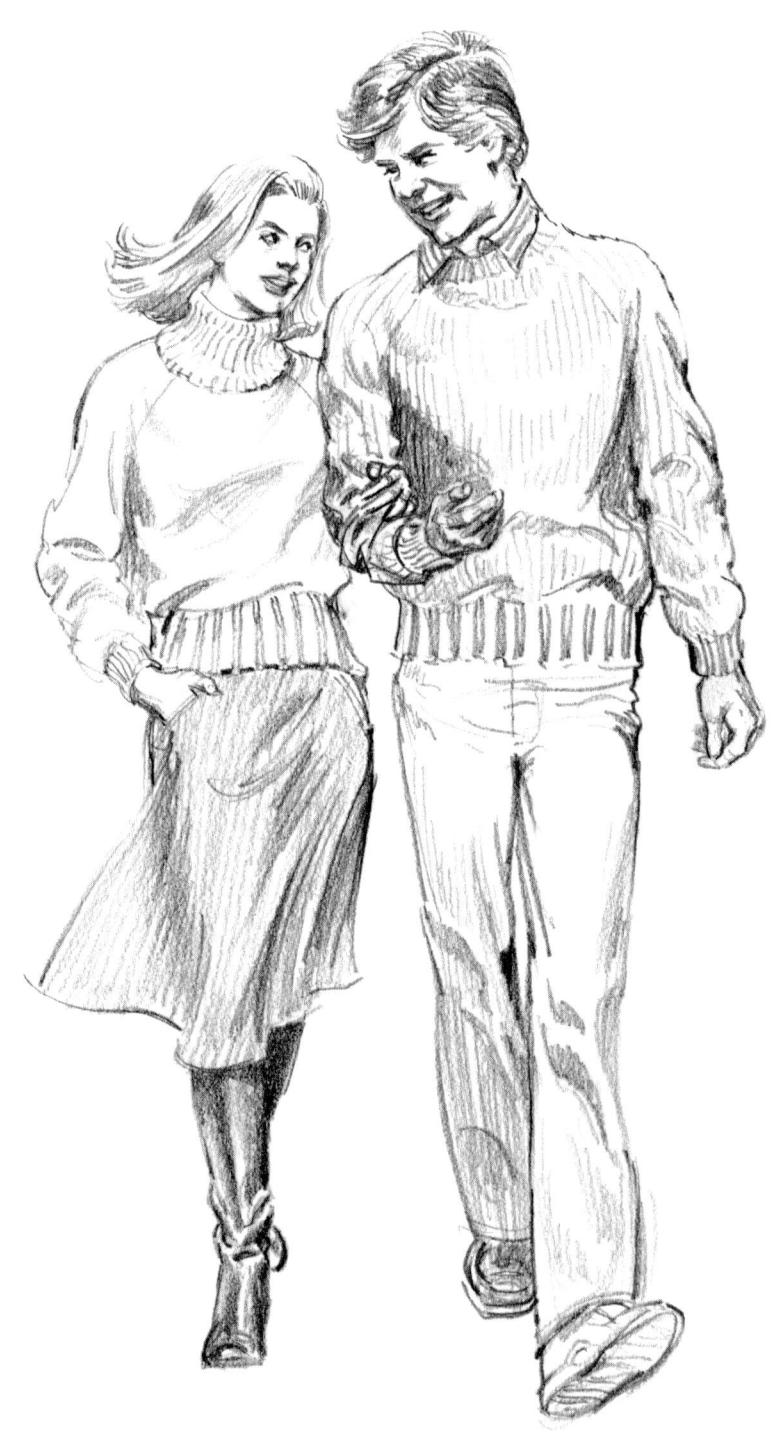

Chapter 7
Clothed Figures

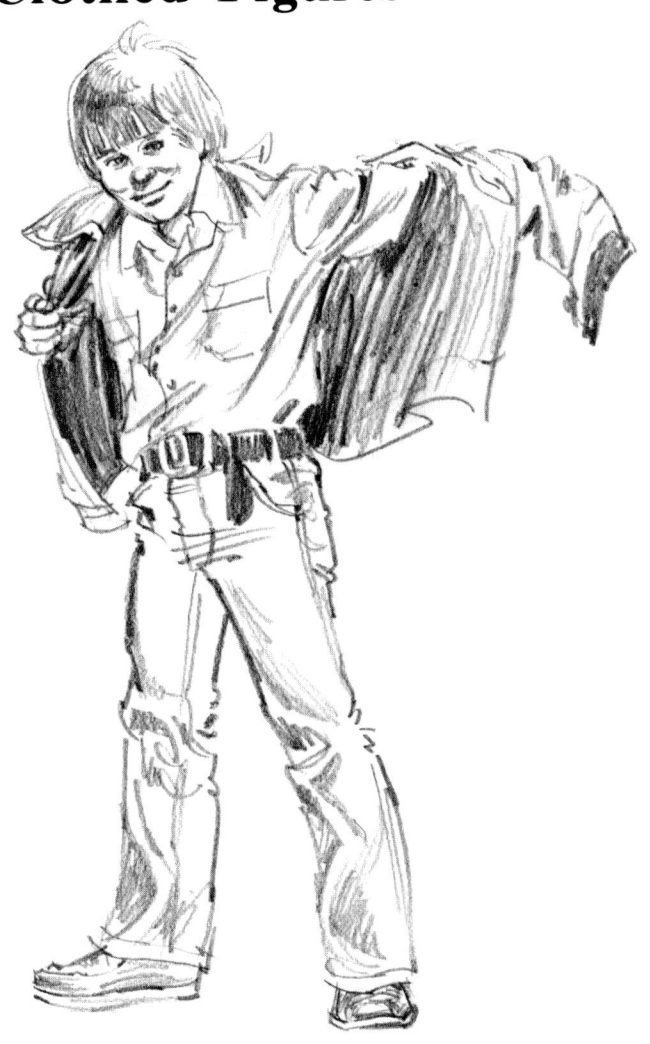

Drawing a figure with clothes may seem very compli-
cated. The cloth folds and turns and wrinkles every way.
But don't be discouraged. It's not as complicated as it
looks. Here is where an artist's ability to "see" is really
tested.

Start off by drawing what you think the model looks like underneath the clothes. Even though you can't actually see, your knowledge of human anatomy will help you. Just a rough sketch drawn very lightly is all you need.

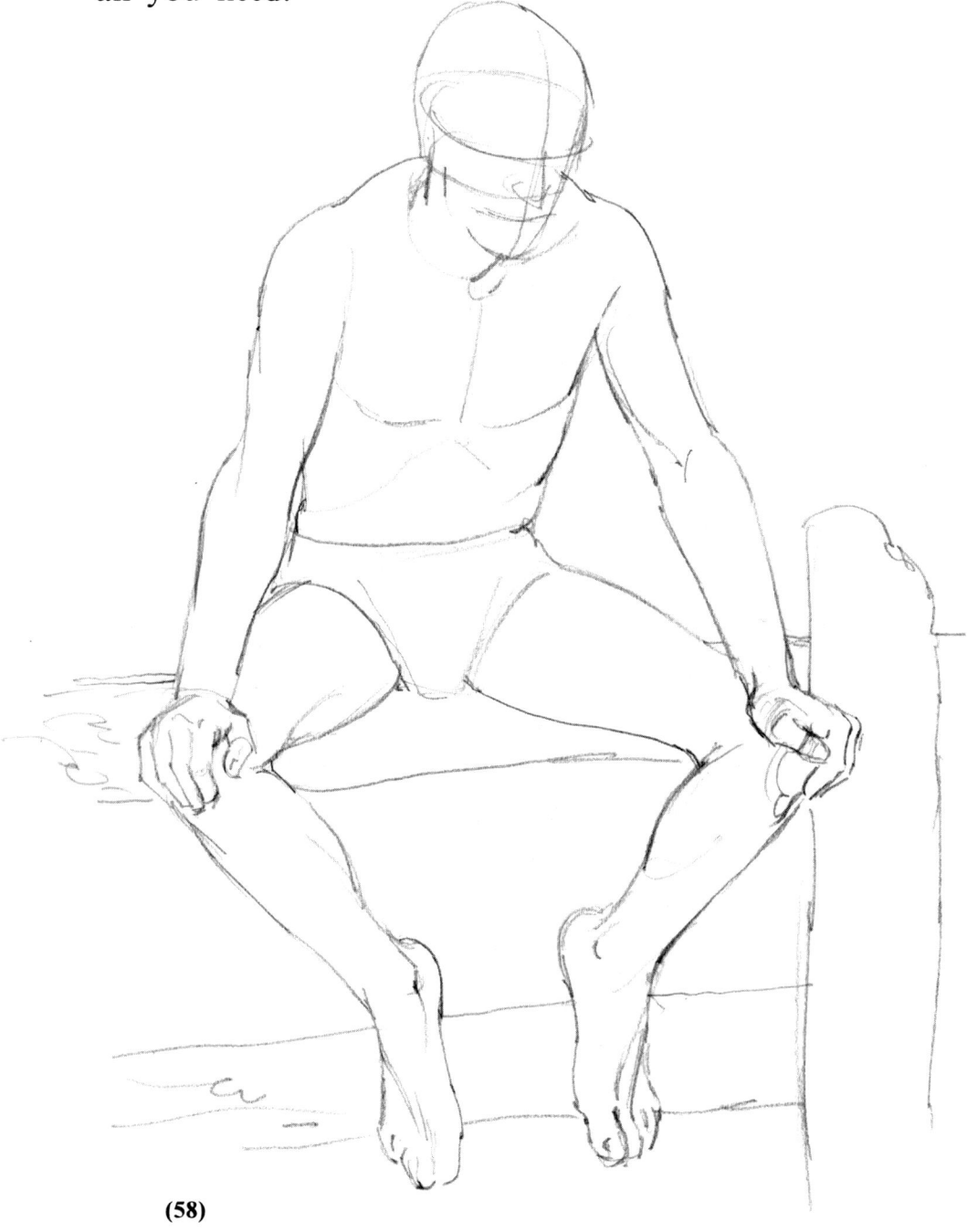

Now begin to draw the clothing over this form. Draw only the folds that do the most to give the feeling that a body is beneath the clothes.

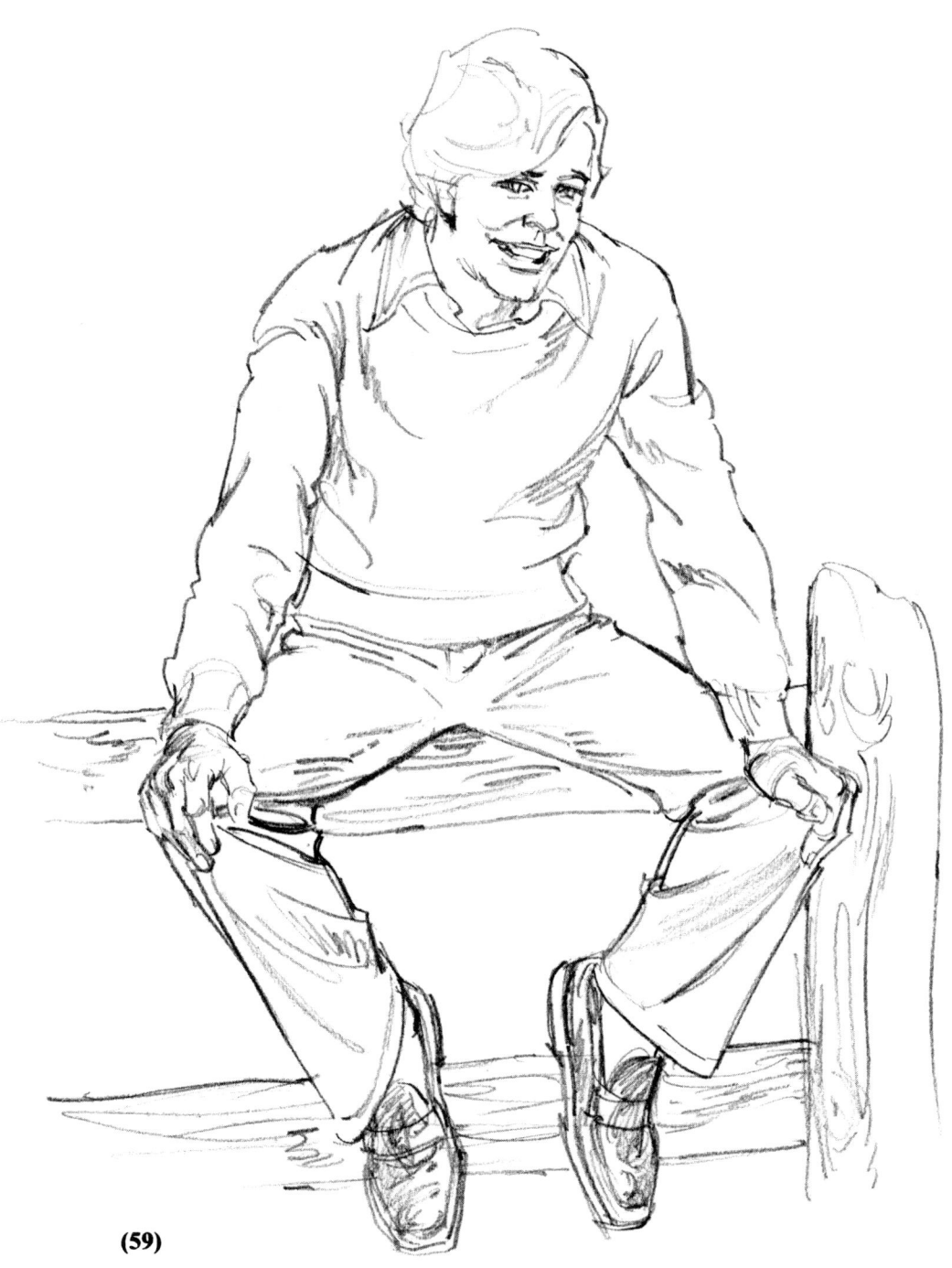

(59)

It will be helpful if at first you light your model from one side only. This tends to keep the light and dark pattern simple. If possible, have your model sit or stand in front of an old sheet or plain blanket. This allows you to see your subject without distractions.

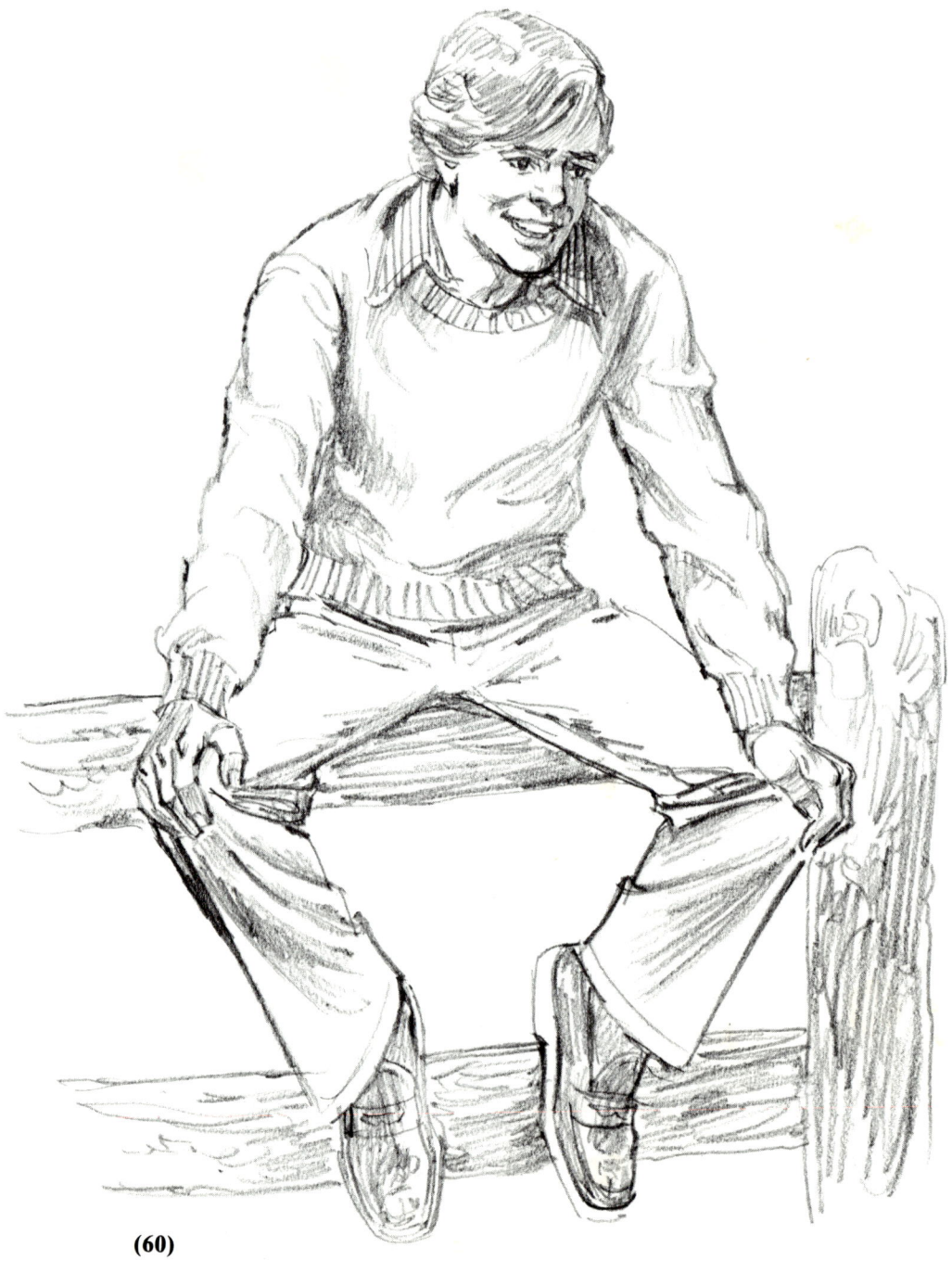

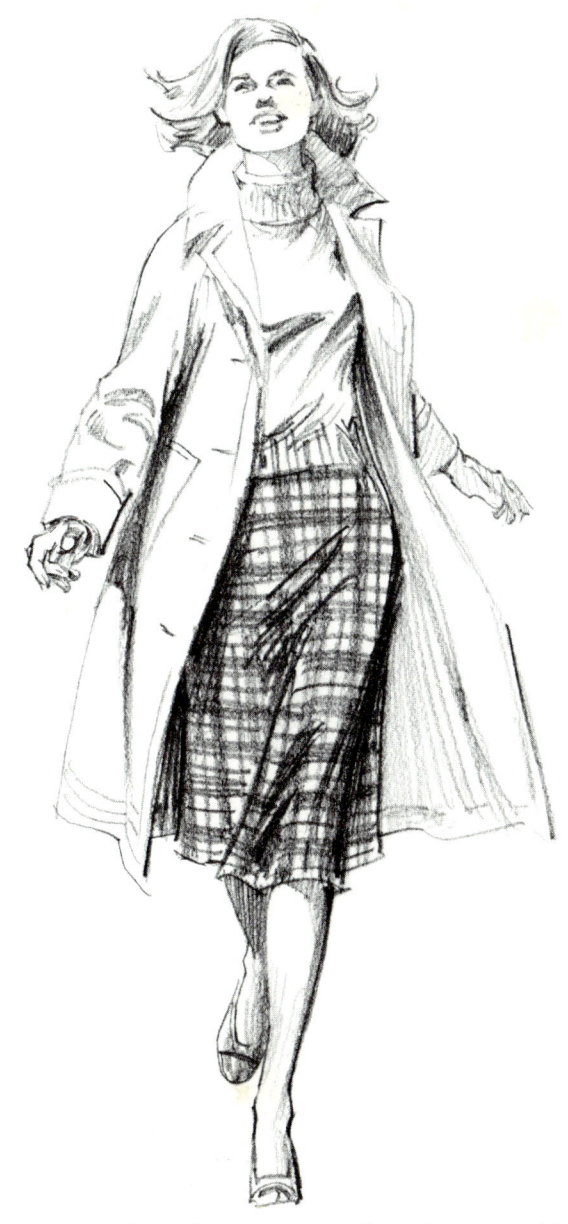

As we said earlier, a drawing is not like a photograph. It needn't include every detail. Pick and choose those details that mean the most in making the figure real. Keep it simple. In a drawing sometimes just a few simple lines can suggest a lot. Use your eyes and your head.

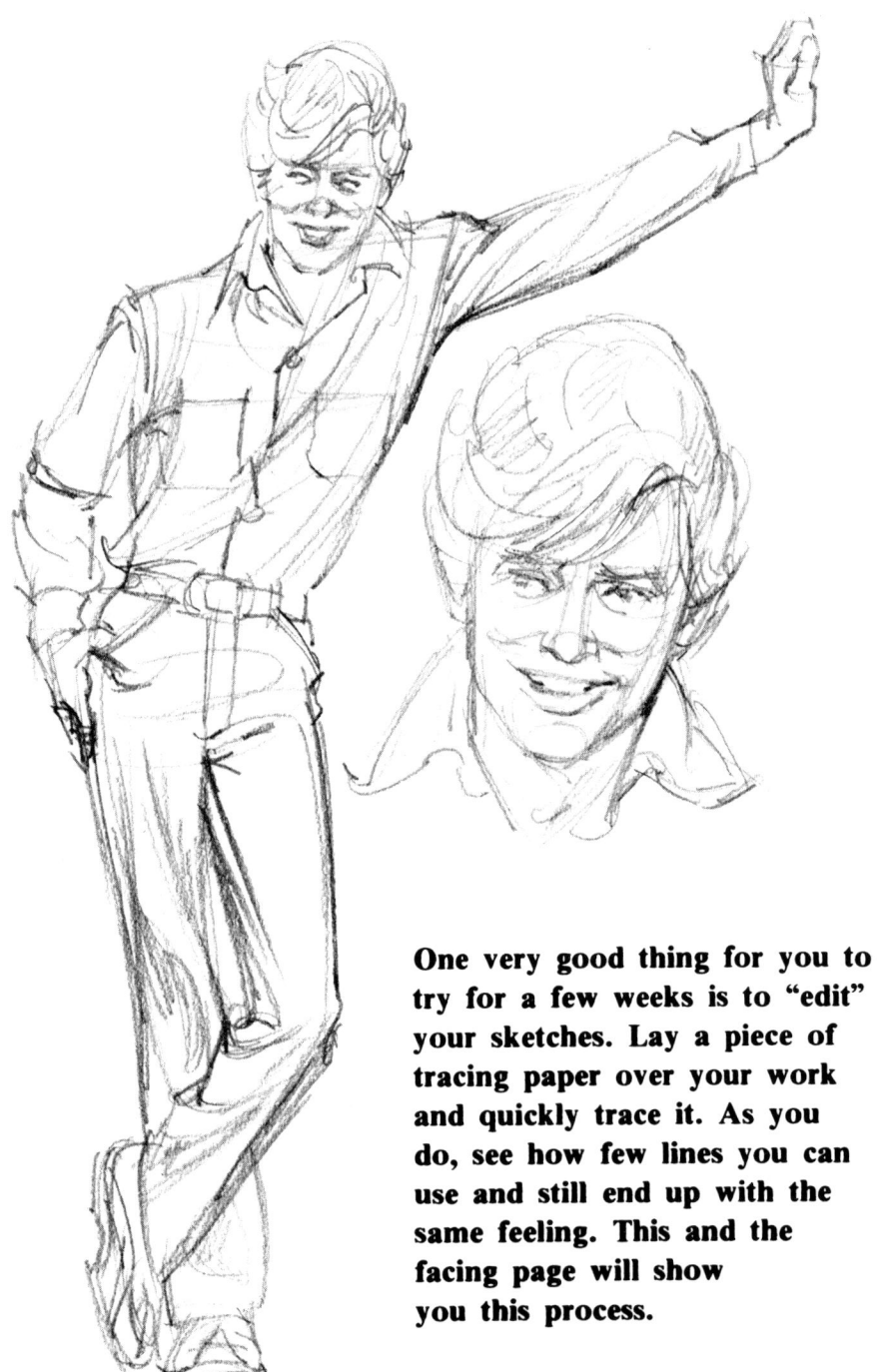

One very good thing for you to try for a few weeks is to "edit" your sketches. Lay a piece of tracing paper over your work and quickly trace it. As you do, see how few lines you can use and still end up with the same feeling. This and the facing page will show you this process.

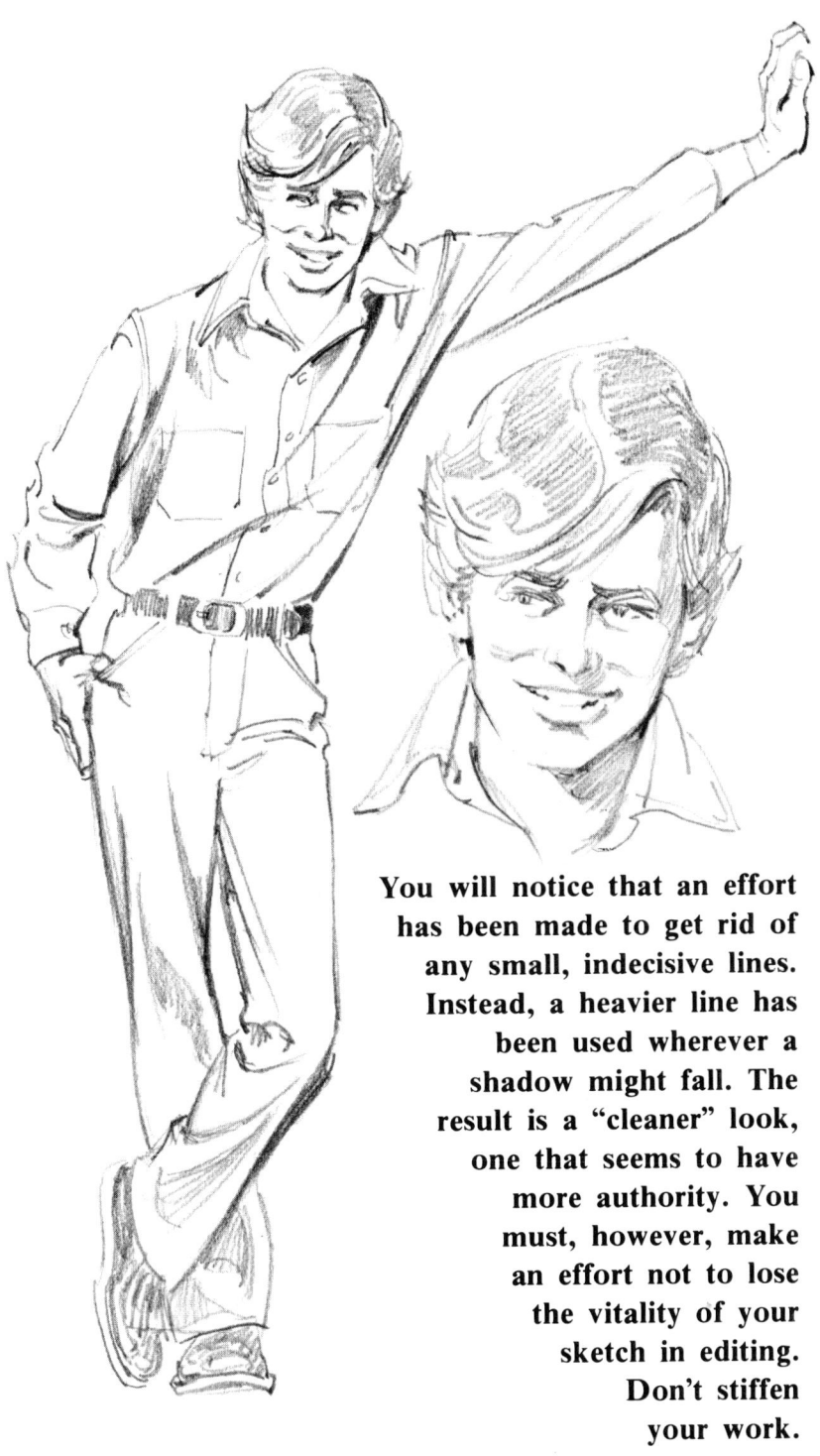

You will notice that an effort
has been made to get rid of
any small, indecisive lines.
Instead, a heavier line has
been used wherever a
shadow might fall. The
result is a "cleaner" look,
one that seems to have
more authority. You
must, however, make
an effort not to lose
the vitality of your
sketch in editing.
Don't stiffen
your work.

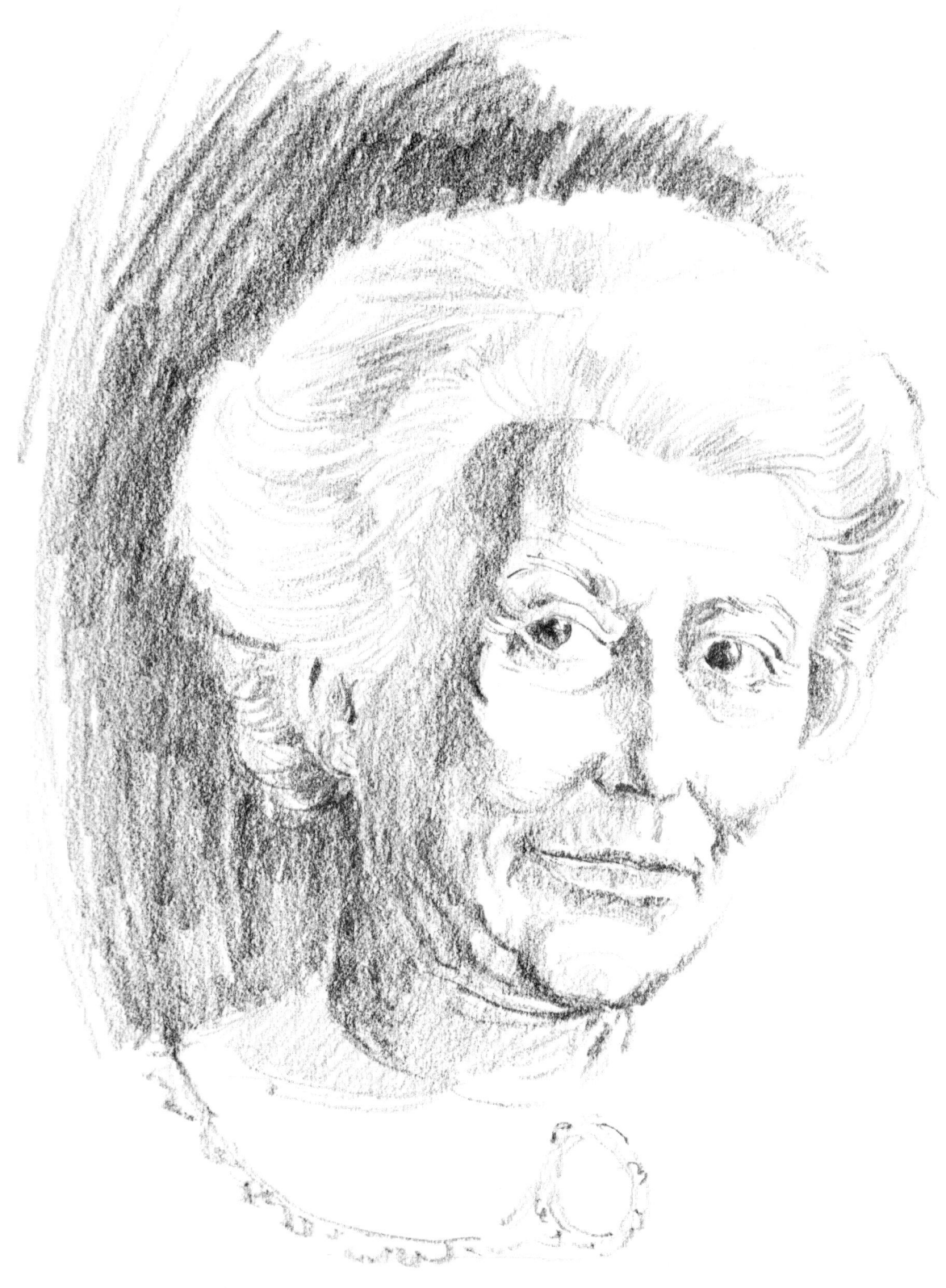

(64)

Chapter 8
Portraits

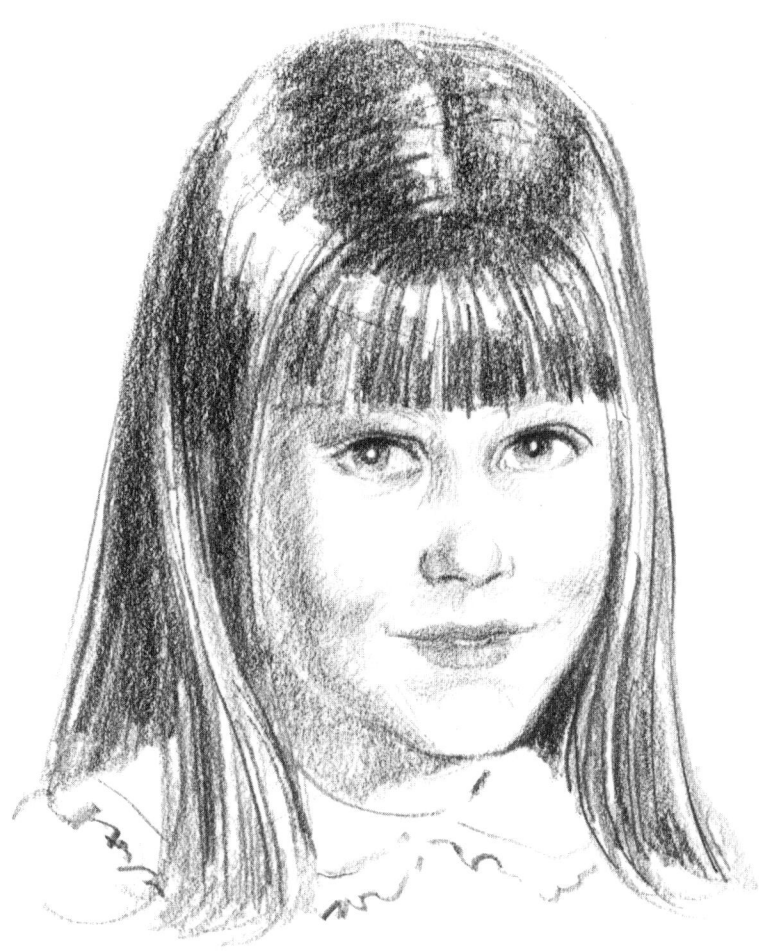

Portraits are the most popular form of figure drawing. People love to see how they look to others. In order to do a good portrait, you must study the person you are drawing very carefully. If the nose is just slightly off or the mouth curves at a wrong angle, the drawing may not look like the person at all. It's the little things that are important here.

There are several things to keep in mind when trying for a likeness. Keep the pose simple and natural — a pose that is comfortable for the subject. Keep the lighting simple, and if possible, from one direct source.

Your first attempts should be three-quarter views, such as the heads on pages 64 and 65. Be particularly careful about basics: Does the subject have an oval, square, or heart-shaped head? How are the eyes spaced — far apart, close, or normal? Carefully note the shape of the eyes and the relationship of one feature to another. Above all, if portraits are your special interest, draw what you see. Don't try to just make an attractive drawing. An important caution: If your drawing is going to be a fairly finished effort, give your model frequent rests — about every ten minutes. Longer poses tend to make your model restless and bored.

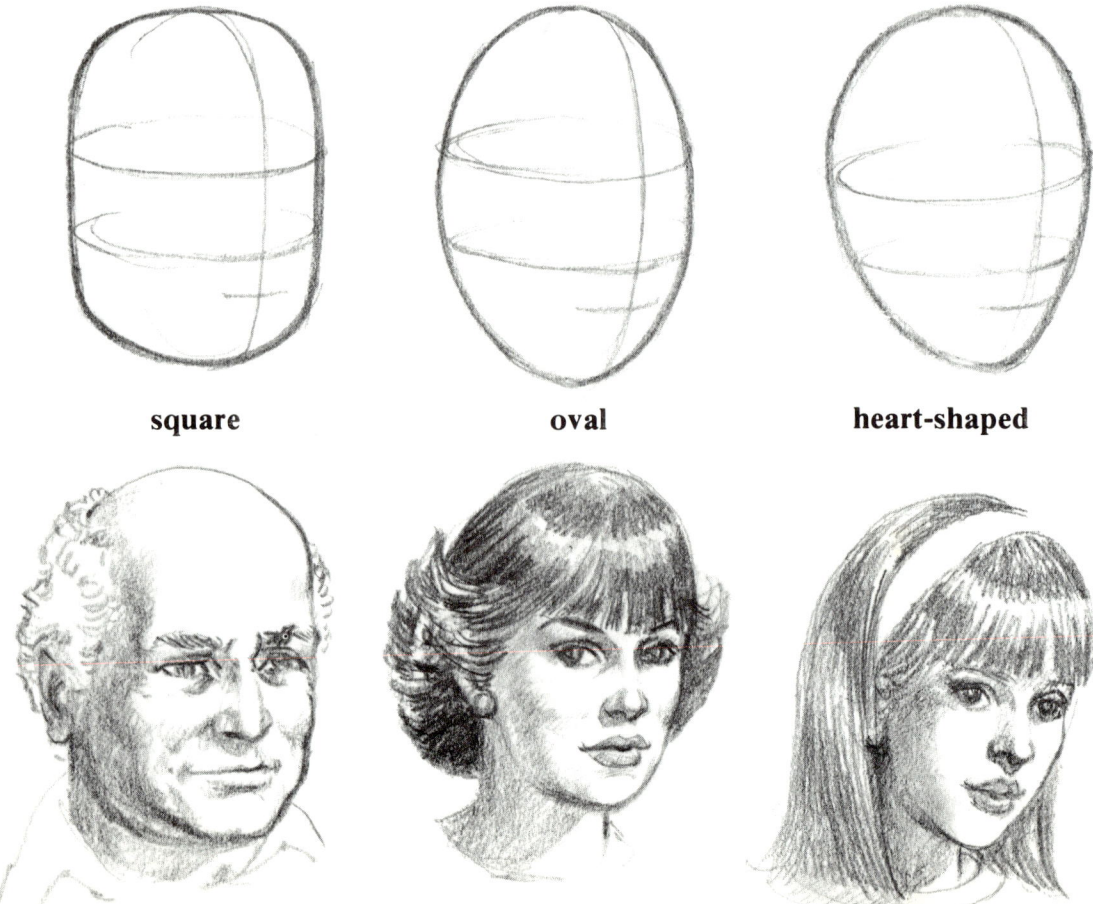

square **oval** **heart-shaped**

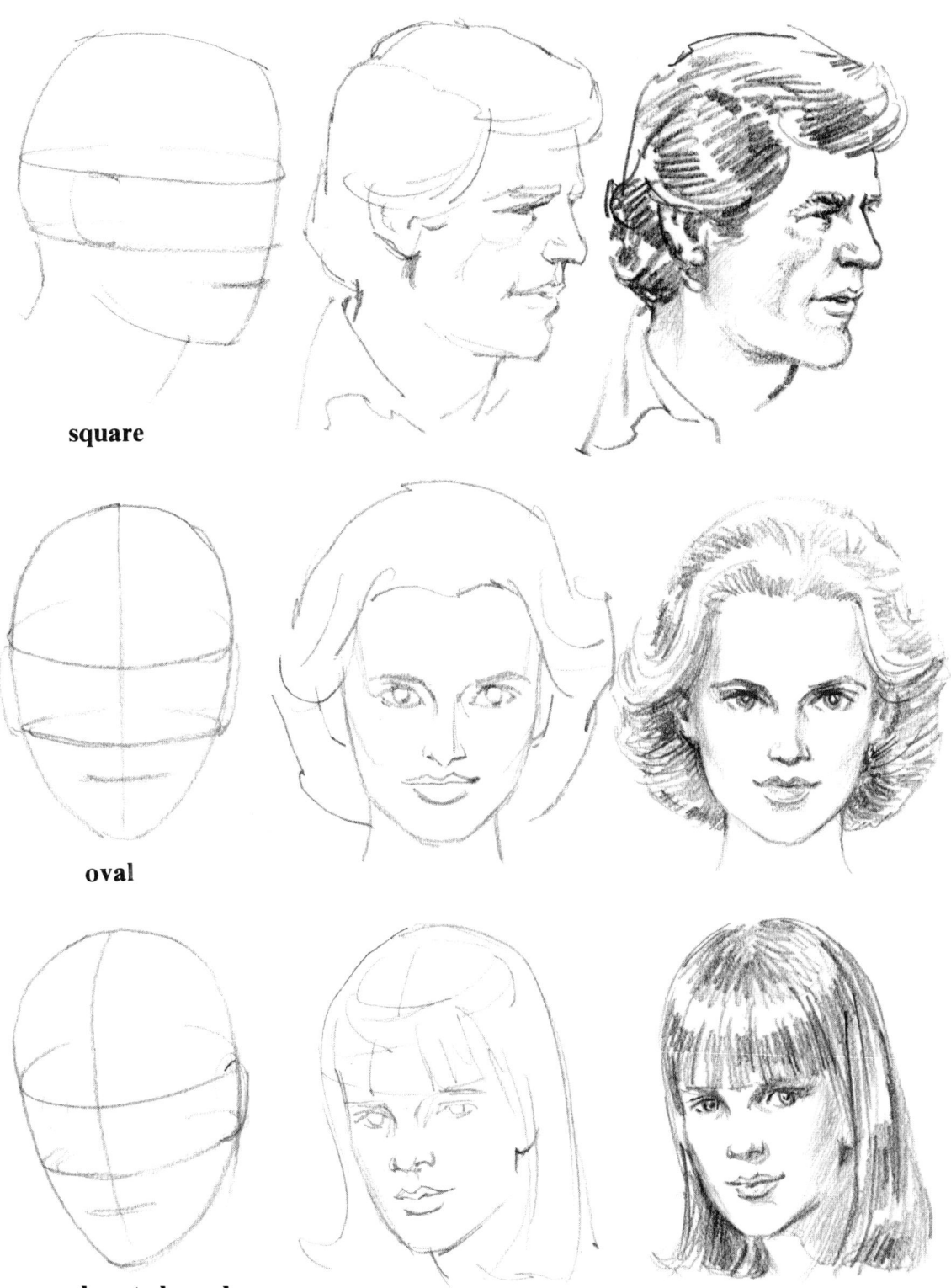

square

oval

heart-shaped

(67)

Afterword

A finished drawing is one that looks like you want it to look. It may take a few minutes, a few days — even a few weeks to complete. It's all up to you.

Sometimes you may want to work longer on a drawing than you really need to, to make it "just a little bit better." This is usually not a good idea. You can often ruin a good drawing by overworking it. It's like tuning the strings on a guitar. Too tight or too loose, and the sound is all wrong.

Drawing people can be a rewarding hobby. But like anything else, it takes effort and patience. For you to be able to stick at it, it must be fun for you to do.

Try to enjoy the process of drawing, not just the results. Think of drawing sessions as a way to relax or a chance to get to know yourself and others better. Good results will be the bonus.

On these last few pages, you will find a group of sketches you can use as a guide for those times that you are unable to find someone to pose.

So have fun and good luck!

(70)

Scho

By **Sarah Harris**

A GROWING number of state schools are charging pupils to eat their own packed lunch in the canteen, teachers warn.

The so-called 'sandwich tax' costs parents up to £2 a day – which supposedly goes towards cleaning and supervision in dining halls.

School leaders said it was a sign of the 'hard financial times' their institutions face. But yesterday the Department for Education slammed the practice as 'unacceptable' and urged families to complain to the schools involved.

The NASUWT teaching union quizzed families about the hidden costs of state education.

Twenty-six out of 2,211 (1.18 per cent) parents who answered a question about school food said their child had to pay to bring in a lunch box this year – with around half charged between £1.50 and £2 a day. This was up from 14 (0.95 per cent) who said there were fees when 1,472 parents responded to a similar survey last year.

Speaking ahead of the union's annual conference in Manchester this weekend, Dr Patrick Roach, deputy general secretary of the NASUWT, said: 'For many parents who are, in the words of the Prime Minister, just about managing, their children may not qualify for a free school lunch.

'Parents are saying "I can't afford the price of a school lunch, I'll send my child in with sandwiches", only to find they're paying between £1 and £2 a day just for right of the child to sit in the